20 Steps to Art Licensing
How to sell your designs to greeting card and gift companies

KATE HARPER

Copyright © 2017 Kate Harper

All rights reserved.

ISBN-13:978-1542433990
ISBN-10:1542433991

To Artists Everywhere

CONTENTS

Step 1: Take a Class
Step 2: Join Online Licensing Groups
Step 3: Read these Books
Step 4: Read these Blogs
Step 5: Look at Trade Magazines
Step 6: Make Art
Step 7: Create Collections
Step 8: Visit Trade Shows
Step 9: Create a Licensing Website
Step 10: Get Feedback
Step 11: Find Companies to Work With
Step 12: Look at Cards in Stores
Step 13: Submit Designs
Step 14: Set up a Monthly Submission Schedule
Step 15: Learn Photoshop
Step 16: Get Legal Advice
Step 17: Look into Agents
Step 18: Get a Planning Buddy
Step 19: Show the World Your Art
Step 20: Expand to Other Products

INTRODUCTION

When I first discovered art licensing, a whole new world opened up to me. It allowed me to loan out my designs to publishers and manufacturers for royalties. Before then, I had been printing, shipping and selling my own greeting cards to over 2,000 stores, including national retail chains. For fifteen years I shipped approximately 25,000 cards a month, and enjoyed the freedom of running my own business and putting my messages out into the world. The only real downside was I discovered that success in self-publishing really boiled down to one thing: You spend a lot of time packing boxes, and very little time creating art. I became intrigued with the idea of letting someone else do all that work, while I received a royalty.

When I started licensing I learned that a card design could also be transferred into a gift item. Eventually my art expanded beyond greeting cards to magnets, coasters, placemats, mugs, embroidery kits, rubber stamps, wall hangings, notepads, towels, bookmarks, and more. This was quite a leap for me, since I had only worked in the

greeting card industry and had never visualized my designs on so many different kinds of products.

It was not easy for me to find information on how to do art licensing. Colleges didn't offer classes on the subject and I learned later that most artists stumble into it by accident. One time at a social event I met a career counselor and explained to her what I did for a living. She was quite fascinated by the information I was sharing and on the spot; she asked if I could come to her college to speak to the students. This is an example of how few people understand art licensing. Even career counselors have not heard of it!

I think one of the reasons licensing is so elusive, is that artists often enter into it through different doors. After years of talking to these artists, I have found they all have unique ways of working. There are few hard rules I consider solid industry standards. Companies differ on what they want, and artists have different styles of working. One designer might do all their work on a computer, and another does everything by hand. Some even employ staff to adapt their art to a variety of products. What stunned me the most was learning that some of the most prominent and successful designers did not have training in art. This convinced me that manufacturers and publishers value quality over credentials.

In this book you will learn the basics of licensing greeting cards, which is an easy stepping-stone to licensing additional gift items. I have provided a list of over 100 publishers who do licensing, along with agents, teachers and other resources I found helpful in my own journey. So if you are interested in licensing, here are twenty steps that can help you go down that road. Most steps are based on my personal experience and from

information I gathered from years of moderating a licensing group in Berkeley, California. We invited agents, legal experts and art directors to teach us the realities of licensing and set up the best conditions for success.

STEP ONE: TAKE A CLASS

It is helpful to take a licensing class in order to get an overview of this career. When I took my first class in San Francisco, the instructor answered many questions and evaluated my art. Later I realized how fortunate I was to have this opportunity, since this type of information can be difficult to find.

Many licensing experts now teach through skype, by telephone, through email and the Internet. Some even have free seminars online or teach at trade shows. This makes access to finding a teacher much easier than when I first learned about licensing. Here are just a few places to take classes in licensing:

Cheryl Phelps
www.cherylphelps.com
cheryl@cherylphelps.com
Cheryl teaches the basics of licensing and helps artists put together a portfolio. She also does phone consultations, online classes and workshops.

The Licensing Expo
www.licensingexpo.com
www.facebook.com/licensingexpo
The event is a trade show that offers classes in the basics of licensing, licensing law, agents, royalties and more.

Surtex Show
www.surtex.com
Surtex is a trade show for surface and textile designers. It offers classes in licensing, how to negotiate contracts, create collections, do publicity and create a portfolio.

STEP TWO:
JOIN ONLINE LICENSING GROUPS

One of the best places I've found to learn art licensing and ask specific questions, is to join online licensing groups. These are especially helpful if you are on a budget or don't have access to professional advice. They are ideal if you run into a roadblock with your designs. You can even ask peers to "vote" on which design, color or text they like the best.

Here are some groups for licensing and greeting card designing:

Art of Licensing Facebook Group
https://www.facebook.com/groups/artoflicensing/

Greeting Card Designer Facebook Group
https://www.facebook.com/groups/greetingcarddesigner/

Linkedin Art of Licensing
https://www.linkedin.com/groups/149470

Total Licensing
Linkedin Total Licensing
https://www.linkedin.com/groups/3969509

STEP THREE: READ THESE BOOKS

Another way to get helpful information is the read the following Books on licensing. Even though some were published years ago, the information is still valid.

Licensing Art 101

by Michael Woodward

This is a handbook that contains information on licensing, reproduction rights, and manufacturers of greeting cards, posters, calendars, and more. Readers learn about: negotiating fees, exhibiting in trade shows, protecting their rights, and more.

Licensing Art and Design

by Caryn R. Leland

This book covers licensing agreements, how to find manufacturers and distributors; and licensing in cyberspace and multimedia and electronic rights.

License to Draw

by Ronnie Walter

This is a book on how to develop the right presentation, essentials of a good contract and a step-by-step explanation of how to dive into art licensing.

STEP FOUR: READ THESE BLOGS

When I first learned about licensing, I found that most of the obstacles I faced could easily be solved by simple online research. Just by reading these blogs, you will also get answers to a variety of detailed questions about art licensing.

Joan Beiriger's Blog on Art Licensing
http://joanbeiriger.blogspot.com/

Art Licensing Blog
https://www.artlicensinginfo.com/art-licensing-blog/

All Art Licensing
https://blogjnet.wordpress.com/

Artsyshark
https://www.artsyshark.com/category/articles/

Maria Brophy's Blog
http://mariabrophy.com

Greeting Card Designer Blog
http://kateharperblog.blogspot.com/

STEP FIVE: LOOK AT TRADE MAGAZINES

The following print and online publications represent news from the gift industry, directed to retail stores as a resource for ordering products. By reviewing them, you will see a variety of cards and gifts items with licensed art. They show you the current market and potential for licensing your designs.

Balloons & Parties
65 Sussex Street
Hackensack, NJ 07601
www.balloonsandparties.com

Christian Retailing
600 Rinehart Road
Lake Mary, FL 32746
www.christianretailing.com

GiftBeat
72 Tappan Road
Harrington Park, NJ 07640
http://www.giftbeat.com

Gift Shop Magazine
195 Hanover Street
Hanover, MA 02339
www.giftshopmag.com

Gifts & Decorative Accessories
360 Park Avenue South
New York, NY 10010
http://www.giftsanddec.com

Giftware New
20 W. Kinzie Street, 12th Fl.
Chicago, IL 60610
www.giftwarenews.com

Greetings Today
Naishville, 1 Church Gates
Wilderness, Berkhamsted
Herts, HP4 2UB
United Kingdom
www.greetingstoday.co.uk

License! Global Magazine
641 Lexington Avenue
New York, NY 10022
http://www.licensemag.com

Museums & More
PO Box 128
Sparta, MI 49345
www.museumsandmore.com

Print Magazine
38 East 29th Street, 3rd Floor
New York, NY 10016
www.printmag.com

Party & Paper Retailer
PO Box 128
Sparta, MI 49345
www.partypaper.com

Stationery Trends Magazine
PO Box 128
Sparta, MI 49345
www.stationerytrendsmag.com

Souvenirs, Gifts & Novelties Magazine
10 E. Athens Avenue, #208
Ardmore, PA 19003
www.sgnmag.com

STEP SIX: MAKE ART

When it comes to creating and selecting designs for licensing, sometimes artists aren't sure where to begin. Your goal is to bridge a gap between your art style and the market place. Rather than just selecting art you have already made, sometimes it's better to begin by first reviewing a company's art submission guidelines. This will help you adjust your design for products.

If you notice that a company's website tends to sell brightly colored floral cards, but your cards are pastels, you might consider adjusting your colors before you contact the company. If they only accept certain sizes, you might need to change the dimensions of your cards. But it is much easier to create a design in the correct dimension from the beginning, rather than change it halfway through.

Here are some typical examples of formatting guidelines from several different greeting card publishers, along with my comments.

Art must be 5x7.

This is a common request. The company only wants designs in a specific dimension. If you designed all your cards in 4½ x 6 it can be time consuming to resize them all, so it's best to know the dimensions up front. I find that it's much easier to reduce a card size rather than increase it, so if you aren't sure what companies you will be working with; it's probably safe to start by doing designs in a 5x7 dimension.

Designs must be vertical.

Companies often don't want art that is in a landscape orientation. They prefer portrait orientation so that the card will open like a book. This is because more cards can fit on a store rack when they are designed in a vertical, portrait orientation.

We prefer borders.

For this company, you could probably just add a border on their existing card design. This might require some tweaking or reduction of the art, so that you can fit a border on the outside of the image.

We want images in sets of 4 with a unifying theme.

This company wants a set of cards that look like they go together. One example of this might be four cards with the same cartoon character or color pallet.

We want complete concepts with copy.

This company wants finished cards with text on it. In this case you want to leave open space in your design and consider what type of text is appropriate for the card. Does it look like a birthday card? Sympathy card? If you don't feel confident in selecting appropriate text, there are several books on how to write greeting card verse. If you feel stumped by this challenge, don't be afraid to just add "Happy Birthday" to a design. Sometimes the simplest message is the most universal.

We only want color submissions.

Obviously, this company does not want black and white images. You will probably need to look carefully at their website to understand why this is the case. Perhaps they only publish photography or gray scaled line work.

All artwork must have spot colors for silkscreen.

This is a good example of why it's important to look at a company's website before designing a card. This company uses a special silkscreen printing process that requires large blocks of color to be printed on separate layers. Artwork with a lot of detail or fine lines will most likely not work for them.

~

By becoming familiar with company guidelines before you make the card, it will save you a lot of time.

But if you have reviewed guidelines and websites, and still aren't sure which one of your styles has the best potential for licensing, I suggest starting with an image you really like, that also has a strong message.

If you have objects in your designs such as flowers, food, animals, cupcakes, etc. that is often easier to license for a card than if you just had a pattern with no central subject or message.

It's obvious that a cupcake image can easily become a birthday card, but also consider florals and animals. Animals in particular, can become the voice of the card speaking to the recipient.

I was surprised to learn that one of the top selling cards at a large company was a humorous photograph of a man in tight shorts. While this image was far from the style of card I designed, it was helpful for me to understand how a picture can communicate a message even before text is added. What was additionally interesting was that this same image was used for a variety of occasions year around. This was done just by changing the text slightly.

It's good to experiment with images that could imagine being used for a variety of occasions, and also to consider how you might add humor. I had a motto for my card business, which was: "If you can make somebody laugh, you have already sold the card."

Easiest licensing themes

My experience has been that Birthday and Thank You

cards are the easiest themes to license. This is because they can be sent year around and are not limited to one holiday or one occasion (like a wedding). Birthday cards in particular, are a good place to start. One greeting card sales representative told me that half of her sales are for birthday cards. This convinced me to spend more time creating birthday cards instead of holiday cards. It wasn't hard to edit my art and transform it into a birthday theme.

For example, here is a card I licensed, that started out as a simple note card with no theme.

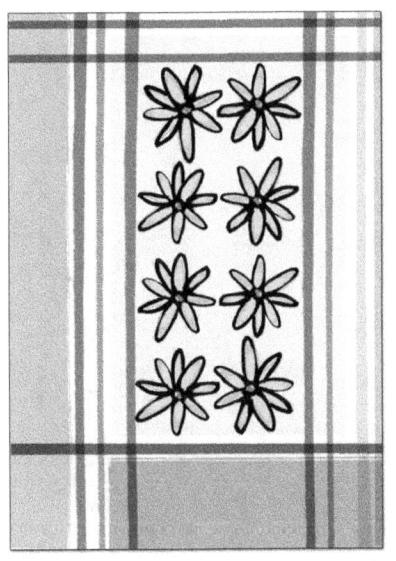 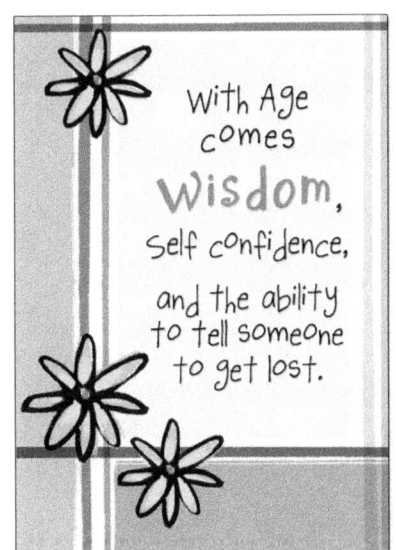

I decided to just move the flowers, open some blank space for text, and add a birthday sentiment inside.

Here are some additional ways you can transform a piece of art into a greeting card:

Change the size

If your art is not in a 5x7 dimension, start by cropping it. If cropping doesn't look good, then select an element in your design as a central focus, and perhaps remove some of the remaining details. Here is an example of how I converted a 7x7 inch piece of art into a 5x7 card, which was eventually licensed and published.

Here is the 7x7 square piece of art I started with. It is a textured background with poppy style flowers.

I first cropped it, removed many of the flowers, and added a large open space for text.

I thought the white space needed to be framed, so I added a border.

I stepped back and evaluated the mood of the card. I thought it might be appropriate for a sympathy card, so I added text to express that sentiment.

Some companies don't request text because they want to write their own. But I tend to offer text anyway to help them visualize a possible message that might go with the image. Sometimes it is good to create a version of your card that is "ready to go" just in case they don't have time to write the text but need an extra card to add

to a catalog.

I also tend to include optional inside text, and perhaps additional imagery, such as the following example.

Here is what the card looked like after the company published it.

They changed my font, edited the text, and adjusted the design. I think these were all great improvements. Their font feels more comforting than my playful bubbly font. My font would be more appropriate for birthdays or celebratory messages. Many companies evaluate cards all day, so I trust their keen sense of skill in deciding what a card should communicate before it is printed.

Add a symbol

If your design style consists of only patterns, collages or abstract art, you can also make a card by just adding a symbol. Symbols help customers understand what you are trying to communicate from a distance of six feet away when it is displayed on a card rack in a store. Here is an example. The card on the left is just an abstract pattern, but the card on the right communicates love or friendship, just by adding hearts.

Even though I don't think this second card needs text on the front, I still submitted two versions of this design, one with text and one without. The company selected the text version and published it as a Valentine's Day card.

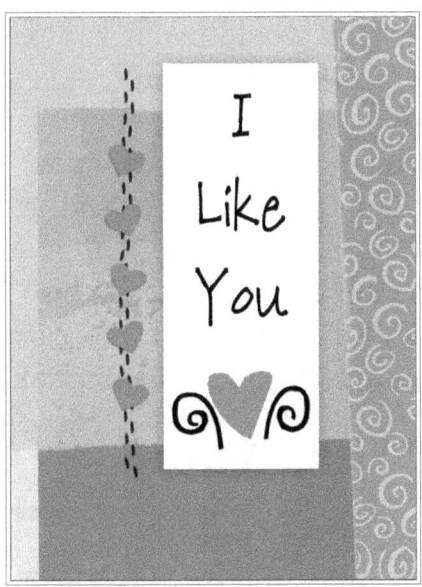

In order to make abstract art into a card, it generally helps to add a symbol to create a sentiment for the card. But if you are licensing art for gift and household items such as napkins, shower curtains, placemats, decorative bags or wrapping paper, a symbolic message may not be necessary.

Add text

When people shop, they mostly buy things for their own household. But people almost always buy cards for someone else. Cards are different than other products because they involve three very important elements: a sender, a recipient and a message between the two. This is why words are so important. The wrong message on a beautiful card can make a potential top seller into a non-seller.

Imagine how you would feel if you received a card in the mail from your sister that said on the front "Everyone makes mistakes." At first you might be confused and incorrectly assume she is saying you did something wrong. But when you open it and read the inside: "People forget birthdays. Sorry I missed yours." Now you understand what she intended to say. She is expressing that "she" made a mistake, not you. A simpler way to communicate this message might have been:

[front] I made a mistake...

[inside]...because I missed your birthday.

This is an example of how a greeting card is a product that is designed for two people, and a message between them.

Some artists create blank cards without text. This can be successful when you have a strong image that compensates for a sentiment. It's obvious that a pumpkin, rabbit or Christmas tree might communicate specific holiday messages, but perhaps you don't want to narrow your design to a specific holiday. Instead, you want someone to buy it for the art, and at any time of year. In this case, ask yourself if the image on the outside allows a person to write a universal message on the inside such as "thank you" or "thinking of you." If so, then the image is probably a good choice for a blank card.

Sometimes artists feel pulled in different directions when creating greeting cards. They want to stay true to their art without viewing it as just a commercial product. Perhaps you see trends in stores and feel the pressure to

follow them. Remember that most products you see were designed over a year ago and will be out of style a year from now, so it's hard to know what the trend will be at any one time. That is why it's good to think about setting your own trends and not worry about what other people are doing.

Whenever I feel influenced by a trend, I look up at my bulletin board and reread this quote I put up over a decade ago. It says, "The crowd is always wrong."

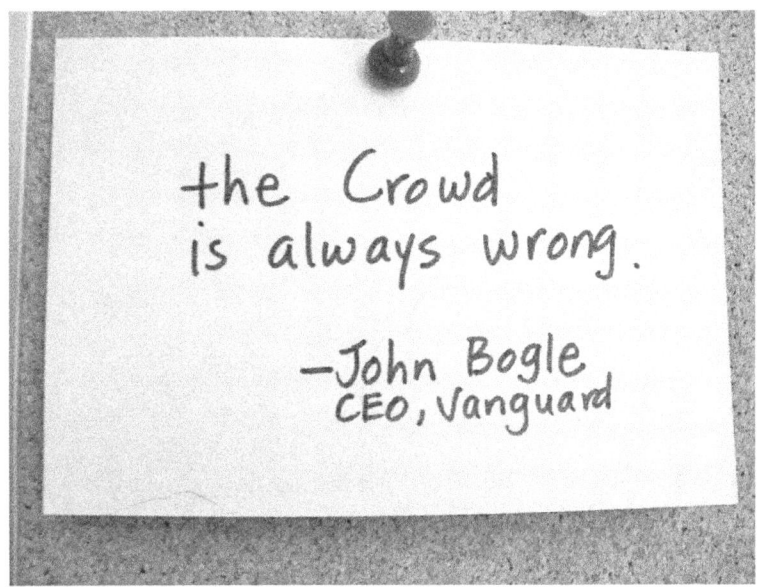

I like this quote because to me it says you should avoid the habit of responding to trends and instead focus on what you like and are good at. The best way for you to accomplish this is to create a design you wish you could buy that is not currently available.

STEP SEVEN: CREATE COLLECTIONS

Most companies like to see cards in a "collection." A collection is a set of cards that look like they go together. They generally have the same basic colors and art style. For example, here are two sets of six cards. The fist set are an assortment of designs that don't look like they go together. Even though I designed them all, they look like they were all designed by a different artist.

The second set is a better example of a collection. They look more unified and designed with a theme in mind.

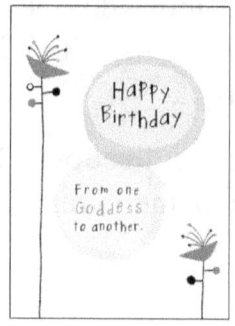

Collections are appealing, just like a matching set of dishes. Even if six cards are all well designed, if they don't look good together, the artwork can appear unfocused. You can still make a variety of styles; just try to expand each style into a set of six cards that look like they all belong together. You can do this by taking one design and making several versions of it.

Here is an example of how to create a collection from one piece of art. Susan Gutnik, a photographer, allowed me to experiment with one of her photographs to see if I could make a collection of six cards. She gave me the first photo of a garden pepper and I used that image to create five additional cards.

This only took me about 15 minutes and reflects how small changes can transform one card into a set of cards. The first image may be the hardest, but the additional five might only take you a very short time.

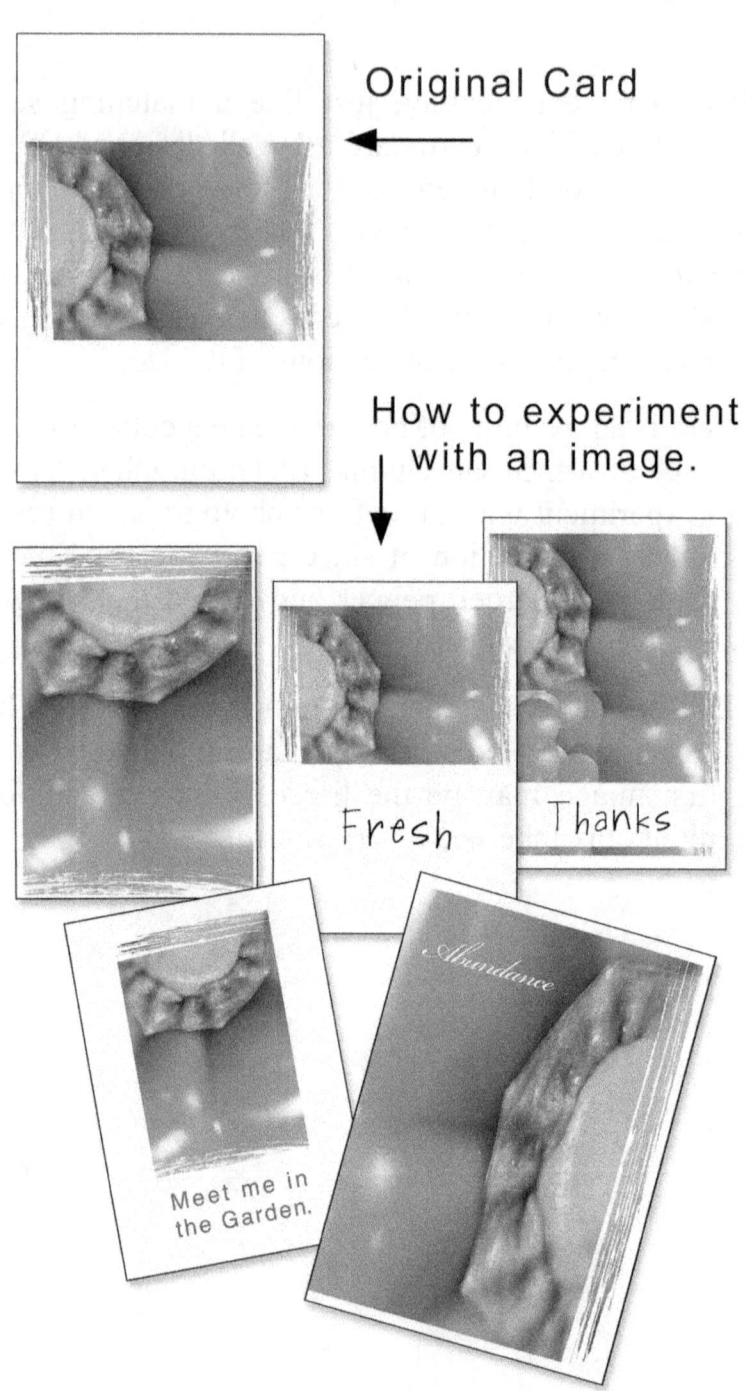

The number of cards in a collection can vary. Some companies might prefer to see four to twelve cards, but if they don't specify a number, I generally send six. Six is large enough to feel like a family, but not so large that it overwhelms a company that does not have time to evaluate large bodies of work.

Tips for creating collections

Here are some simple ways to create a collection from one card:

Change the Image Size

The first way you can create a collection from one card is to change the size of the primary image. In this example I've taken an image of two small cats on one card, and increased the size of one individual cat on the second card. You can experiment by putting different sizes of the same object on several cards.

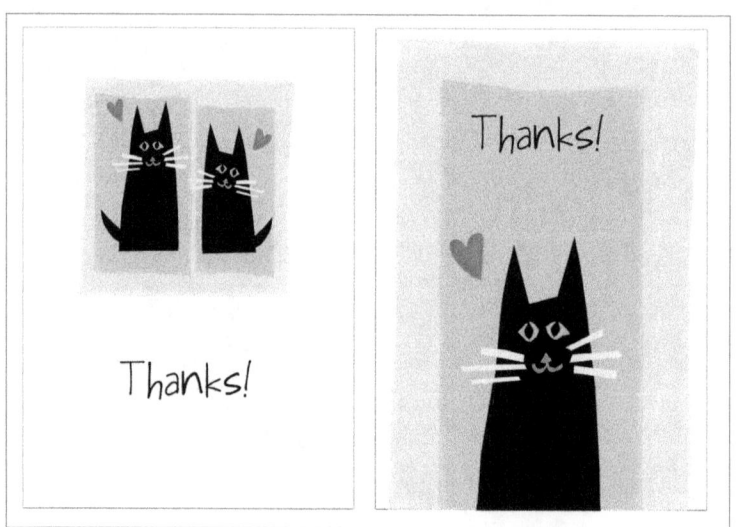

Rotate Dominate Colors

Another way to create a collection is to emphasize different dominant colors from you pallet. If you have six main colors in your card, select a different color to dominate each card. For example, one card might have a

lot of lemon yellow in the background, another one has turquoise, and a third might have a border with your burnt orange. Just make sure the color pallet choices are the same on each card.

Change Text Length and Sentiment

You can also create a collection by changing the text on each card. Rather than having every card say "Happy Birthday," you can develop sentiments with a different number of words such as "May you have a wonderful birthday!" You can also direct the sentiment to different people. One might be a romantic partner, another a friend, such as "Happy Birthday to my sweetheart" and "Happy Birthday to a special friend."

Add Different Versions of an Image

Another way to create a collection is to add more image styles to your primary theme. If you have a card with one flower, substitute a different kind of flower on the other five cards. If you have a rubber stamp image of an animal, add different animals with the same rubber stamp texture. If you have a coffee cup, use a different cup on each card.

Change the Number of items

If you have a central object, like a daisy, you can have a different number of those objects on the five additional cards in the set. In one card you might have one daisy flower, another card might have two, and so on.

Add Patterns

Also consider adding different patterns. If you have a border around an image, you could add different kinds of patterns on the border, such as stripes, polka dots, etc.

These are just a few tips on how you can create a collection from one image. You can combine one or more of these tips simultaneously to add even more variety.

The only two things I suggest not changing are the color pallet and the font style. Try to make these consistent on all six cards.

In the following example, it's possible to use completely different patterns in the background, and as long as the font and color pallet is the same, it can still appear to be part of a collection.

All of the tips and examples above can be applied to any gift items such as mugs, magnets or kitchenware. The goal is the same: Try to make a set of images that look like a set that belongs together.

STEP EIGHT: VISIT TRADE SHOWS

At some point on your licensing journey, it's really helpful to visit trade shows. You will see a variety of greeting card and gift wholesale businesses displaying products to retail store buyers. Looking at products at a trade show is very different from seeing products in a magazine, just like visiting a beach is different from looking at a postcard . You may have a sense of what the beach is like, but until you go there, you don't really see the additional benefits of the experience. At a trade show you have the potential to meet artists, agents and publishers. You will also experience the general buzz and excitement of this creative industry. You also often have the opportunity to take classes.

Here is a list of recommended card and gift industry trade shows.

National Stationery Show
New York, NY
http://www.nationalstationeryshow.com

The Supply Side
New York, NY
http://www.thesupplyside.com

Dallas Total Home & Gift Market
Dallas, TX
http://www.dallasgiftshow.com

Atlanta International Gift & Home Furnishings Show
Atlanta, GA
http://www.americasmart.com

The Craft and Hobby Show
Rosemont, IL
http://www.craftandhobby.org.

California Gift Show
Los Angeles, CA.
http://www.californiagiftshow.com

New York International Gift Fair
New York, NY.
www.nyigf.com

The Licensing Expo
www.licensingexpo.com
www.facebook.com/licensingexpo

Surtex Show
www.surtex.com

STEP NINE: CREATE A WEBSITE

These days, it's pretty essential for most designers to have a website. There are many things to consider such as cost, technical skills, ease of use, storage limits, support, and what services you might need.

This is a vast subject that can be understood better by reading specialized books on the topic. I am only going to cover some basic tips I recommend when creating a site specifically for greeting card and gift licensing.

Decide the goals of your website.

Before setting up your site, it is helpful to ask two questions: Who do you want to visit the site? And what do you want them to do once they arrive?

Ideally, the people you want to visit your site are manufacturers and publishers. They are your ideal "customers" who might license your art. There's nothing wrong with fans or friends visiting your site, but keep in mind the primary purpose is to appeal to the

manufacturer. Some artists sell items or offer classes to the public and include this information on their site. This is fine as long as it does not distract the visitor from your ultimate goal, which is licensing.

Some people build great websites and attract a lot of visitors, but they neglect to think about what they want the visitor to do once they arrive. Research shows that most visitors leave websites when they aren't sure what to do next, or they can't find something.

On a licensing website there are three things you want to happen: First, you want to encourage the visitor (publisher) to view as much of your art as possible in a very short time. Second, you want to make it easy for them to contact you. Third, you want to develop a relationship. Here are some tips on how to accomplish These three things:

Viewing your art: Make your case in one minute.

Some people find it shocking to learn that the average visitor only spends one minute on a website and 15 seconds per page. This means they will probably only view four pages. It is very sobering to know this ahead of time if you have grand plans to create multiple pages and subpages. Evaluate the information you want to put on your site and then ask, "what are the most important four pages?"

Since viewing art is a priority, you want the visitor to locate your images easily from the home page. This can be done by naming a tab on the navigation bar "portfolio."

Make it easy to contact you.

You also want to make it easy for the publisher to contact you, so include a "contact" tab on your navigation bar, and post your contact information at the bottom of every webpage on the site. All contact information (including the bottom "footers") should be an active link, so when the visitor clicks it, they can send you a message.

Build a relationship.

You want to develop a relationship with the company visiting your website. Perhaps they are not ready to contact you yet, and just want to lurk at a distance. They might be interested in your art, but once they leave the site, they might forget your name and where your site is. One way to keep your site on their radar, is to offer a simple sign up form. You can even send out a monthly newsletter of new designs.

Also consider including links to social networks such as linkedin, facebook, twitter and instagram, assuming of course, these are only business accounts (and not personal accounts).

Create good navigation.

I have learned in web design classes that a common mistake people make when setting up a website, is to spend too much time creating an attractive site, but

neglecting the ease of navigation. Poor navigation examples are too many tabs, poorly labeled links, or forcing a visitor to click through several subpages to find something.

Some licensing websites with good navigation might only four tabs with simple labels:

| Home |Portfolio| About |Contact |

They might not sound sexy, but they allow the visitor to reach their goal fast.

Navigation checklist for an art licensing site.

• A visitor can find your card images and contact page with just one click from the homepage.

• The tabs have clear names, such as "Portfolio" rather than "Explore," for example

• The site is primarily for greeting cards, and not a mixture several different businesses, such as an added side-gig of your accounting services.

• Your logo is in the upper left of every page, and when the visitor clicks it, they return to the homepage.

• You have an image of your art on your homepage that represents your unique and interesting style.

• A 10-year-old child can tell you what each link will lead to without clicking on it.

- Your images load in about one or two seconds.

- You avoid auto-play videos, animation, unexpected sounds and pop-up windows. And you don't force visitors to click boxes that say "skip this" or "turn it off."

- From the moment a person lands on your homepage, they can locate and view at least 30 of your images in about 30 seconds. If not, this might mean your images are too hard to find, the pages take too long to load or your images are on too many different pages.

- For greeting cards images, avoid forcing the visitor to click on each card image to read the inside text. Instead, post the text under the card so they can scan an entire page of cards and read the text without clicking.

- Create an easy way for visitors to sign up for mailing lists. Avoid long forms and allow them to merely sign up with just an email address and name.

How to set up a website.

I did a survey of card designers who have websites and asked them how they set up their websites and what companies they used to host their site. The list below is a result of that survey. It does not represent all the options available. It is just a sampling from a variety of artists with different needs. Each artist had different priorities. Some just want a free site they could put up fast. Others wanted a shopping cart and a large site with all the bells and whistles.

Shopify: www.shopify.com
Bluehost: www.bluehost.com
Weebly: www.weebly.com
Wordpress: www.wordpress.com
Webs.com: www.webs.com
Big Cartel: www.bigcartel.com
iPage: www.ipage.com
Godaddy: www.godaddy.com
CafePress: www.cafepress.com
Blogger: www.blogger.com
HostGator: www.hostgator.com
Wix: www.wix.com

STEP TEN: GET FEEDBACK

Once you've finished creating some collections and have researched different options for a website, seek out feedback on your designs before you put them on the site. If you are on a budget, you can join a greeting card and licensing artists' community group to get feedback. You can also hire a licensing consultant.

When asking for feedback in online groups, request honest advice on how to improve your designs. For example, you could post "This is my first card collection, how can I improve it?" or " What should I drop and what should I expand?" Try to get as many detailed opinions as possible. I often ask people to vote on which version they like and why. This usually leads to a wealth of responses that are very helpful, and in some groups, agents and publishers drop in every now and then to give feedback. I've found these groups to be very beneficial, especially if I get stuck and can't decide which direction to go.

If you prefer to work with a licensing consultant, here is a list of people who work in the art licensing industry. Their fees vary and some offer free online classes.

Licensing Consultants

Jeanette Smith
All Art Licensing
www.allartlicensing.com
www.facebook.com/allartlicensing

Sheila Meehan
www.meehandesigngroup.com
www.facebook.com/MeehanDesignGroup
Consulting for product development in licensing, contracts, portfolio reviews

Carolyn Edlund
www.artsyshark.com
www.facebook.com/ArtsyShark
Consulting for marketability of your art, presenting your art, website review, mentorship.

Ronnie Walter
www.ronniewalter.com
Coaching to guide you through the development of a portfolio and presentation, monetizing, find markets for your products.

Melissa Schulz

www.artlicensinginfo.com

www.facebook.com/ArtLicensingInfo

Free interview series, trend reports, online group classes, offer one-on-one coaching for including portfolio reviews and overall direction in regards to licensing.

STEP ELEVEN:
FIND COMPANIES TO WORK WITH

It is much easier to get a licensing contract if you first select the right company. For me, that meant a company who liked text, humor and bold colors, but not one who only publishes photography, watercolors or blank cards. Even if I had a top selling design at one company, another company may not be able to sell that design, because they serve different types of customers.

If a manufacturer's specialty is animal images and they primarily sell to pet supply stores, then floral designs may not have relevance to their customer base. But if the floral designs were changed to include animal imagery, perhaps that would be a better match.

Here are some actual examples of art stylest companies request. Notice how some differ dramatically:

We prefer photos in black and white.

We like retro themes and woman to woman.

We like images that are representative of the southwest lifestyle.

We want cute, fun, and brightly colored icons like cats, flowers and household objects.

We only look at photographs of wildlife in their natural habitat.

We want cute critters such as animals and teddy bears.

We want timeless scenes of landscapes, cottages and Victorian subjects. No cute cartoons please.

We are looking for funny adult humor, hot men and women.

Perhaps you see some companies that fit your art style.

The first time I licensed cards, I spent about two weeks researching several companies before deciding on which ones I wanted to approach. I spent an additional two weeks exploring how to prepare my submission. Even though I spent a month doing these two things, it was worth it because in the end I got a large contract for several cards on my first licensing attempt.

Take time to research what companies best fit your art style. Otherwise, even with great card designs, you will have little chance of getting a contract if you approach the wrong company.

So how do you know which company is a good match? Start by categorizing the characteristics of your

cards. Here are just a few examples of different categories cards fall into:

> Character based or cartoon art
> Animals and pets
> Fine Art
> Quotations or calligraphy
> Photography
> Collage
> Blank (no text)
> Retro
> Religious and Inspirational
> Western Art
> Line drawings
> Handmade
> Snarky and humorous.

Once you determine your art style, you will probably know immediately whether a company is a good match. A company who only publishes photography is not going to be a good choice for your cartoon art. And if you make handmade cards with added embellishments like glitter and bows, there are only a few specialized companies that license and manufacture this type of product. But perhaps you can also adjust your card design and replace an embellishment with a drawing. Then you can expand your company list.

Identifying your theme will help narrow down what

companies you want to approach. Start by selecting companies from the following list that look like a good match. Even if it takes you a month to complete this task, it will significantly increase your chances of success.

Note: Each company has two links, one is to their homepage, and the other is to the submission guidelines page. Companies sometimes change their guidelines link, so if you cannot find the guidelines, go to the homepage and locate it in one of the following ways: Look under FAQ Frequently asked questions, "Contact" page, "About" page, the footer of the webpage and search for the words: Submissions, Guidelines, or Artists.

Greeting Card Companies

Allport Editions Artist Guidelines

https://www.allport.com/

Guidelines:

https://www.allport.com/join

Avanti Press

http://www.avantipress.com/

Guidelines: Look under contact+submission guidelines.

http://www.avantipress.com/get-in-touch/submissions/photo-submission

Amber Lotus

http://www.amberlotus.com/

Guidelines:

http://www.amberlotus.com/submission-guidelines.html

Artists To Watch
http://www.artiststowatch.com/
Guidelines:
https://www.artiststowatch.com/art.html

Abacus
http://www.abacuscards.co.uk/
Guidelines:
http://www.abacuscards.co.uk/content.php?id_content=3

Bayview Press
http://www.bayviewpress.com/
Guidelines:
http://www.bayviewpress.com/submitart.html

Brush Dance
www.brushdance.com
Guidelines:
http://www.brushdance.com/artist-submissions/

Blue Mountain
http://www.sps.com
Writer Guidelines:
http://www.sps.com/help/writers_guidelines.html

Comstock Cards
http://www.cmpmarket.com/
Artists and Writer Guidelines:
http://www.cmpmarket.com/guidelines.php

Crown Point Graphics
http://www.crownpointgraphics.com/
Guidelines:
http://www.crownpointstationery.com/artists.html

Calypso Cards
www.calypsocards.com
Guidelines:
http://www.calypsocards.com/AboutUs/Submissions

Caspari
http://www.casparionline.com
Guidelines:
http://www.casparionline.com/Artist-Submission-Guidelines.html

C.R. Gibson
www.crgibson.com/
Guidelines:
https://www.crgibson.com/e2wCustomerTemplate.aspx?url=documents/html/FAQ_Artist.htm

Design Design
http://designdesign.us/
Guidelines:
https://www.designdesign.us/webforms/index/index/id/2/

Designer Greetings
http://www.designergreetings.com/
Artists and Writer Guidelines: Look under "opportunities" tab

Dayspring Cards
http://www.dayspring.com
Writer Guidelines:
http://about.dayspring.com/corporate/contact/editorial.asp

Ephemera

http://www.ephemera-inc.com/

Writer Guidelines

http://www.ephemera-inc.com/category-s/123.htmhttp://www.ephemera-inc.com/category-s/123.htm

Fotofolio

http://www.fotofolio.com/

Guidelines:

http://www.fotofolio.com/contact/contact.html

FStop

http://www.fstopimages.com/

Guidelines:

http://www.fstopimages.com/pages/license-images/

Felt

https://feltapp.com/

Artist Submissions: designers@feltapp.com

Great Arrow Graphics

http://www.greatarrow.com

Guidelines:

https://www.greatarrow.com/designers/guidelines.htm

l

Gina B

http://www.ginabdesigns.com

Guidelines:

http://www.ginabdesigns.com/images/2016artistguidelines.pdf

http://www.ginabdesigns.com/Scripts/PublicSite/?template=Contact

Gallison/Mudpuppy

http://www.galison.com

Guidelines:

http://www.galison.com/About-GalisonMudpuppy-W7C0.aspx

Hotchpotch

http://www.hotchpotchpublishing.com

It Takes Two

http://www.ittakestwo.com/

Guidelines: http://www.ittakestwo.com/artists.html

Just Wink

https://www.justwink.com/app

Guidelines:

http://corporate.americangreetings.com/contact.html

Koala Publising
http://www.koalapublishing.com.au
Guidelines:
http://www.koalapublishing.com.au/Content_Common/pg-artwork-contact.seo

Leanin' Tree
http://www.leanintree.com/
Guidelines:
http://www.leanintree.com/artsubmission.html

Legacy Greetings
http://www.legacygreetings.com
Guidelines:
http://www.legacygreetings.com/static/legacy/designs.asp

Madison Park Greetings
http://madisonparkgroup.com/
Guidelines:
http://madisonparkgroup.com/contact/submit-art/

Minted (Crowdsourced Contests)
http://www.minted.com/
Guidelines:
http://www.minted.com/design-challenge

Nobleworks

http://www.nobleworkscards.com/

Artist and Writers Guidelines:

http://www.nobleworkscards.com/nobleworks-greeting-cards-submission-guidelines.html

Oatmeal Studios

http://www.oatmealstudios.com/

Artists:

http://www.oatmealstudios.com/html5/pages/art_guide.html

Writers:

http://www.oatmealstudios.com/html5/pages/writers_guide.html

Palm Press Photography Submission Guidelines

http://www.palmpressinc.com

Guidelines:

http://www.palmpressinc.com/ppsite/photosubmit.php

Pictura, Inc.

http://www.picturausa.com/

Guidelines: Send to Ramona.coughlin@picturausa.com

Paper Rose
http://www.paperrose.co.uk/
Artists and Writer Guidelines:
https://www.paperrose.co.uk/Pages/Page/3

Papyrus (Same as Recycled Paper Greetings)
http://www.prgreetings.com/
Artists and Writer Guidelines:
https://www.papyrusonline.com/customer-services/faq#qB

Paper House
http://www.greatbritishcards.co.uk
Artists and Writer Guidelines:
http://www.greatbritishcards.co.uk/artists-enquiries/

Pumpernickel Press
http://www.pumpernickelpress.com
Guidelines: Pdf at:
http://www.pumpernickelpress.com/DSN/wwwpumpernickelpresscom/Content/Artist%20Guidelines.pdf
or see FAQ page:
http://www.pumpernickelpress.com/47/faq.htm

Peaceble Kingdom Press
http://www.peaceablekingdom.com/
Guidelines:
http://www.peaceablekingdom.com/contact/artist-submission

P.S. Greetings/Fantus
http://www.psg-fpp.com
Artists and Writer Guidelines:
http://www.psg-fpp.com/creative_guidelines.htm

Planet Zoo
http://planet-zoo.com/
Guidelines:
http://planet-zoo.com/photo-submission/

Pomegranate
http://pomegranate.com
Artists and Writer Guidelines:
http://pomegranate.com/arsub.html

RSVP Sellers
https://www.rsvp.com
Artists and Writer Guidelines:
https://www.rsvp.com/faq/

Smart Alex
http://www.smartalexinc.com/
Artists and Writer Guidelines:
http://www.smartalexinc.com/pages/artist_submission/124.php

teNeues
http://www.teneues.com
Artists and Writer Guidelines:
http://www.teneues.com/shop-us/contact.html

Thankster
http://www.thankster.com/
Guidelines:
http://www.thankster.com/contents/view/submit_yours

Tree Free
http://www.tree-free.com

Up with Paper
http://www.upwithpaper.com/
Guidelines:
http://www.upwithpaper.com/faq/jobs-and-careers/

UK Greetings
http://www.ukgreetings.co.uk
Artists and Writer Guidelines:
https://www.ukgreetings.co.uk/creative-submissions/

Vialbella Greeting Cards
www.viabella.com
Artists and Writer Guidelines:
http://viabella.com/marianheath/links/Submission_Guidelines.pdf

Vigo Productions
http://www.vigocards.com/

Licensing Art for Gifts Items

Artaissance
http://www.artthatfits.com
Guidelines:
http://www.artthatfits.com/art/ForArtists.aspx

Art in Motion
http://www.artinmotion.com/
Guidelines:
http://www.artinmotion.com/Content/Detail/SubmitYourArt

Arts Uniq'
http://artsuniq.com
Guidelines:
http://artsuniq.com/guidelines.asp

The Art Group
http://www.artgroup.com
Guidelines:
http://www.artgroup.com/artist-services/submit-art/

Ad-Lines
http://www.ad-lines.com
Fill Out form: http://www.ad-lines.com/

Andrews McMeel
http://www.andrewsmcmeel.com/
Guidelines:
http://www.andrewsmcmeel.com/submissions.html#_submissions

Brown Trout publishers
http://www.browntrout.com
Guidelines:
http://www.browntrout.com/submissions

Barrington Studios
http://barringtonstudiosltd.com
Guidelines:
http://barringtonstudiosltd.com/bsl/submission.html

Bentley Publishing Group
http://www.bentleyglobalarts.com
Guidelines:
http://www.bentleyglobalarts.com/home/submissions

Bottman Design
http://bottman.com
http://bottman.com/contact

Bonartique
http://www.bonartique.com

Canadian Art Prints
http://www.canadianartprints.com
Guidelines:
http://capandwinndevon.com/licensing/licensing-for-artists/

Chronicle Books
http://www.chroniclebooks.com
Guidelines:
http://www.chroniclebooks.com/our-company/submissions/adult-trade

Cape Shore
http://www.cape-shore.com
Guidelines:
https://www.cape-shore.com/artist-submissions

Carpentree
http://carpentree.com

Daisy Company
http://www.daisiecompany.com/

Decal Girl
http://www.decalgirl.com
Guidelines:
https://www.decalgirl.com/workwithus/licensing/

Design Ideas
http://www.designideas.net
Guidelines:
https://www.designideas.net/Work-with-Us/

Editions Limited
http://www.editionslimited.com
Guidelines:
http://www.editionslimited.com/submitart.asp

Elsa L
http://www2.elsal.com
Guidelines:
Look under Contact Tab/Art Submissions

Fiddlers Elbow
http://www.fiddlerselbow.com
Guidelines: licensing@fiddlerselbow.com

Gelaskins
http://www.gelaskins.com
Guidelines:
https://www.gelaskins.com/pages/faq

Galaxy of Graphics
http://www.galaxyofgraphics.com
Guidelines:
http://www.galaxyofgraphics.com/submit.php

Garven
http://garvenllc.com
(See contact page for "freelance art" submissions.)

Graphique de France
http://www.graphiquedefrance.com
(Scroll to bottom of page to "Art Submissions")

Gift Wrap Company
http://www.giftwrapcompany.com/
Guidelines:
https://www.giftwrapcompany.com/about-us/

Gallison/Mudpuppy
http://www.galison.com
Guidelines:
http://www.galison.com/About-GalisonMudpuppy-W7C0.aspx

Hollins Gifts
http://hollinsgifts.com
Guidelines:
http://hollinsgifts.com/artist-submission/

Hay House
http://www.hayhouse.com
Guidelines:
http://www.hayhouse.com/artwork_submissions.php

Icon Shoes
http://www.iconshoes.com
Guidelines:
http://www.iconshoes.com/faqs.asp
(Scroll down to "how are images selected")

Kurtovich
http://kurtovich.com
Guidelines:
http://kurtovich.com/contact-details/
email art samples to kevin@kkprod.co.nz for approval, and they present to buyers.

The Lang Company
http://www.lang.com
Guidelines:
http://www.lang.com/frequently_asked_questions#g2
(Scroll down to "Art Submissions")

Leisure Arts
http://leisurearts.com
Guidelines:
http://www.leisurearts.com/design-submission-guide/

Masterpiece Puzzles
http://www.masterpiecesinc.com
Guidelines:
http://www.masterpiecesinc.com/AboutUs/ArtistSubmissions.aspx

Moda Fabric
http://www.unitednotions.com
Submit to:
cfreydberg@unitednotions.com

Meadwestvaco
http://www.mead.com
Guidelines:
http://www.mead.com/mead/faq
(Scroll down to "General questions")

Nouvelles Images
http://www.nouvellesimages.com
Guidelines:
http://www.nouvellesimages.com/artists-79.html

Oopsy Daisy
http://www.oopsydaisy.com
Submit to: artist@oopsydaisy.com

Phoenix Trading
https://www.phoenix-trading.co.uk
http://www.phoenix-trading.co.uk/web/corp

Pine Ridge Art

https://www.pineridgeart.com

Guidelines:

https://www.pineridgeart.com/generic.htm?ecinfo=faq

(Scroll down to "General FAQ.")

Plaid Craft

http://www.pgrahamdunn.com

Guidelines:

http://plaidonline.com/ideas/default.aspx

Peter Pauper Press

http://www.peterpauper.com

Guidelines:

http://www.peterpauper.com/submission.php

Robert Kaufman

http://www.robertkaufman.com

Guidelines:

http://www.robertkaufman.com/artwork/

SunsOut, Inc.
http://www.sunsout.com
Guidelines:
http://www.sunsout.com/contact-us/
(See Product Submissions Section)

Trends International
http://www.trendsinternational.com
Guidelines:
https://trendsinternational.com/artwork-submission/

Toland Home Garden
http://www.tolandhomegarden.com
Guidelines:
http://www.tolandhomegarden.com/Scripts/PublicSite/?template=contact_thg

Unicorn Graphics
http://www.unicorngraphics.com
Guidelines:
http://www.unicorngraphics.com/unicorn/submission.asp

US Games
http://www.usgamesinc.com
Guidelines:
http://www.usgamesinc.com/pages.php?pageid=11

Warner Press
http://www.warnerpress.org
Guidelines:
http://www.warnerpress.org/custom.aspx?id=3

York Wallcoverings
http://www.yorkwall.com
Guidelines:
http://www.yorkwall.com/static/other/contact
(Fill out form and select "art submission inquiry" and you will receive a pdf.)

STEP TWELVE: LOOK AT CARDS IN STORES

Another way to find a company that matches your style is to visit stores and look at gift and stationery items. For example, if you do animal themes, go to a pet store. Pick up an item and turn it over and find the label to see what company manufactured it. Contact them and see if they do licensing. Some companies do not publicly request art submissions, but they still do licensing.

KATE HARPER

STEP THIRTEEN: SUBMIT DESIGNS

As mentioned earlier, companies often specify how they want to receive art submissions. Here are some examples of specifications I pulled directly from a variety of company guidelines. I've also added my comments.

All artwork must be sent digitally through email.

This company requires that you send a digital copy of your designs (vs. printout). Your digital files will most likely need to be in a specific file type (ex: jpg, pdf, tif) and resolution.

Sent artwork as pdf file.

Your art will need to be saved in a specific pdf format before sending it. This can be done in most software programs by saving a copy or your work in the pdf format.

Put 2-4 images on each page.

This company wants a few images on each 8 ½ x 11 page. You can usually get two cards on one page at full size, or you can reduce the size, and get four cards on one page.

Name and contact information must be on all artwork.

This company wants your name on everything you send. We will talk about how to do this digitally later.

We accept color printouts.

You can print your images and mail them to the company through surface mail.

Send low-res files. Do not send large graphic files.

This company wants copies of your art formatted in a small file size so they won't take up a lot of computer space or require long download time.

Email three images as jpgs.

This company wants a limited amount of images in a certain digital format, and then emailed. We will discuss formatting jpgs in the following section.

Submit art though our online form.

This company does not want you to send surface mail or email them anything. They want you to upload your art through a special form on their website.

Don't send attachments. Cut and paste your images into your email.

This company wants you to email your submission, but they don't want you to attach a file to the email. It's possible that they are trying to avoid computer viruses, or they prefer seeing art in the body of the email (rather than downloading it). In this case, you do not want to attach anything to your email; instead just copy your image and then paste it into your email message.

Do not send your work by email. It will not be reviewed.

This is an example of how companies have very different preferences. One company only wants email, and another may never want email.

Only send your website link (no facebook links)

This company wants to see a website of your art, but they don't want to go to a social media link where images are often mixed with messages. They prefer a dedicated site with a portfolio where they can

evaluate your art.

Do not send original artwork.

Almost every company posts this message in ALL CAP letters: "DO NOT SEND ORIGINAL ARTWORK." I can only assume artists often send companies the only copy of their art. This can cause a multitude of problems. The artwork can get lost or damaged and it's not reasonable to expect a company to keep track of the art and expect them to incur the cost of returning it.

Send color copies or CD's.

This company gives you a choice of making color printout of your designs, or putting them on a CD.

If sending by snail mail, send SASE or it will not be returned.

If you mail art to this company through surface mail, they will not return it unless you send them a self addressed stamped envelope.

Common ways to submit art

After reviewing company submission guidelines, you might start to notice there are some common ways they like to receive art. It pretty much boils down to these four:

1. Through email.

2. By postal (snail) mail.

3. Through an online form.

4. By evaluating your website.

Many companies allow you to submit art in more than one way. When I first started licensing, most companies requested I mail designs through the U.S. mail or FedEx. Not long after, these same companies switched over and started requesting artists only send digital files through email. I learned how to properly scan, format and digitize my art for each company. This was a big learning curve for me because all of my art is handmade.

Tips on submitting art by email

Most companies today like to receive art digitally through email. They usually request low resolution (low-res) files first for previewing. If they like your designs in the preliminary submission and want to license them, they will then ask for a high-res version of that same image. [IMPORTANT: Do not reduce your original art to low-res. Always make a copy of your original art first, before changing the resolution].

Low-res files

Low-res files allow a company to download and store art easily. If you have ever downloaded a video to your computer, it usually takes a long time because the file is so large, and just a few videos can take up a lot of storage

space on your computer. But if you download a written document, it is much faster and takes up very little storage space. The same is true for art files. It is better to send a small file that can be downloaded quickly and does not require a lot of storage space.

There are several ways to reduce file sizes (not to be confused with image dimensions) so that the company can easily receive the art.

Companies sometimes have different definitions of what low-res means, but in general, it is safe to assume they want a small file size in a jpg (or jpeg) format.

jpg format

Beside a low resolution, companies often request images to be sent in a jpg file format. If you want to know what format your image is already in, look at the extension of the file name. For example, here are four file formats of the same image: flower.jpg, flower.png, flower.psd, and flower.gif.

Name	Size
flower.jpg	2.8 MB
flower.png	4.9 MB
flower.psd	6.3 MB
flower.tif	7.4 MB

Even though all these images look about the same to me when I open them up, they have been saved in

different formats. Notice how each file is dramatically different in size, and that the jpg image is much smaller than the rest. One reason companies request jpgs, is that jpg file sizes are smaller and easier to download. But a more important reason is that jpgs can be opened on most computer operating systems and in a variety of software programs.

Here's a fun challenge:

Which of the following files do you think would be the best choice to send a company when you submit art?

Name	Size	Kind
picture1.tif	7.4 MB	TIFF image
picture2.psd	3 MB	Adobe Photoshop file
picture3.jpg	109 KB	JPEG image
picture4.psd	8.8 MB	Adobe Photoshop file
picture5.jpg	379 KB	JPEG image
picture6.jpg	3.1 MB	JPEG image

If you selected file *picture3.jpeg* then you are correct.

Out of the six files, three are in formats other than jpeg, so you can eliminate them (psd and tiff files).

Out of the three remaining jpegs, there are three different file sizes: 109KB, 379 KB and 3.1 MB. The smallest file is 109 KB.

Don't confuse kilobytes (KB) with megabytes (MB). A MB is a 1,000 time larger than a KB. If you can get images under 500KB, that is great. 100KB is even better.

Don't get too bogged down by all these numbers. The main goal to aim for is to just make the file sizes small and in a jpg format (so the company can download them easily). An artist who sends very large image files (example 10 MB) will probably appear unskilled and a company might mistakenly conclude the artist does not have enough technical skills to work with.

The common way to create a jpg file is the use the SAVE AS function in most programs, then select jpg.

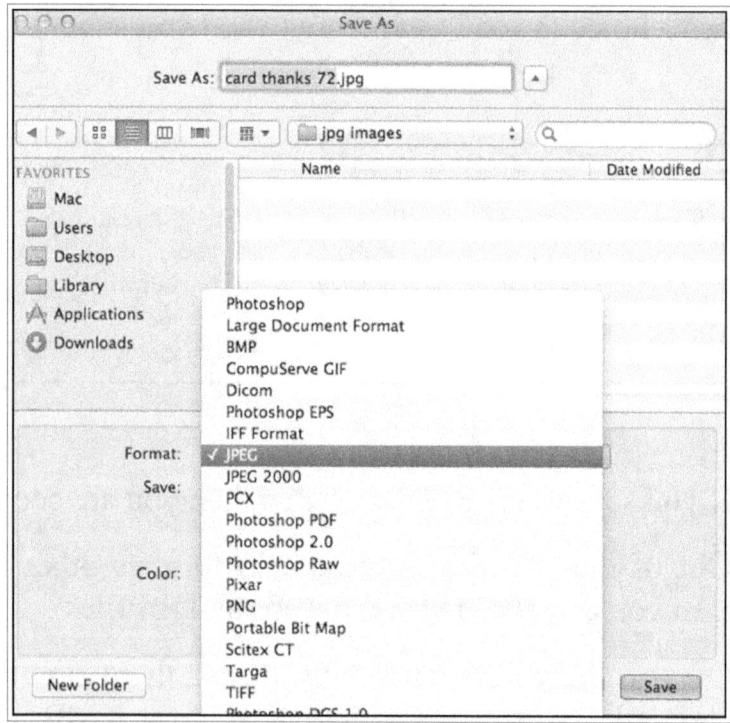

Even smaller?

If your jpg image is still large (over 500KB) you can also make the file smaller in some graphic software programs by using "SAVE FOR WEB DEVICES" instead of "SAVE AS" which is intended for reducing files for the web.

Another way to reduce your file size is to select one of the jpg options when you save an image. This dialogue box in Adobe Photoshop software allows you to reduce your image to low, medium or high file size. The numerical size will change on the lower right.

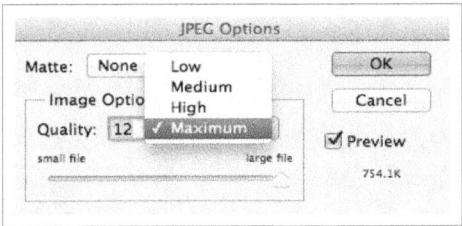

Here is an example of that same image that has been saved in low, medium and high quality. It's a pretty significant difference in file size (on the right).

Name	Size
image option quality Low.jpg	162 KB
image option quality Medium.jpg	261 KB
image option quality High.jpg	950 KB

Changing resolution.

Some companies specifically request what image resolution they want you to send. The most common one is 72. Almost every graphic software program has a way to change the resolution. In the Photoshop software program, you can do this by selecting IMAGE on the menu bar and then the IMAGE SIZE in the pull down menu. Then change the resolution from 300 to 72. [Reminder: only change resolutions on copies of your art, not the original]

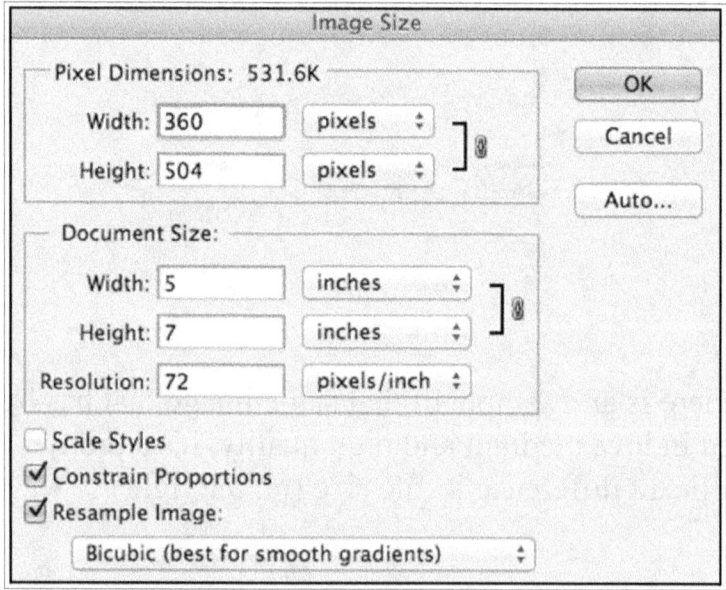

Notice how the file size has been reduced almost 75% when you change the resolution.

Name	Size
card-thanks-high-res-300.jpg	926 KB
card-thanks-low-res-72.jpg	224 KB

Put contact information on your art

Most companies want you to put your name and contact information on all your art. When submitting digital image files, that can be a challenge because you can't just write on the backside like you might a printout. Companies deal with many pieces of art by hundreds of artists, so if one of your images gets mixed in with other submissions, and it is easy to lose track of who the original artist was.

What I suggest, is to embed you contact information into the digital art, and include your name on the computer filename.

How to embed contact info on a digital file.

You can embed your contact information on the bottom or side of the art. This will avoid it interfering with your design. Here are two examples:

Put your name on the file name.

Also include your name as part of the digital file name like in this example:

kateharper_bd_retro_crazy.jpg
kateharper_bd_retro_goddess.jpg
kateharper_bd_retro_age.jpg

This helps a company search for art under your name and identify who the art belongs to.

I've also noticed that greeting card companies often use common codes for certain types of cards such as bd (birthday), toy (thinking of you), ty (thank you). You might also use simple abbreviations for card occasions.

Because some computer operating systems differ in the way they read file names, here's some helpful tips for naming files:

• Use lower case letters such as "flower" and not "FLOWER"

• Use underscores to separate words and not blank spaces. red_rose_photo is better than red rose photo and red_flower is also easier to read that redflower.

• Use only letters and numbers. Avoid punctuation in your file name such as red_rose:1 and instead use something like red_rose_1

• Include a group name. For example, here is an example of how I named a collection of birthday cards using "bd" at the beginning.

bd_retro_crazy.jpg
bd_retro_goddess.jpg
bd_retro_age.jpg

A benefit of naming files clearly, is that you will

know what the image is, without opening it. In the prior file names, I know what they are without opening them.

The .jpg extension tells me they are images and not a spreadsheet (.xls) or text (.doc). The bd tells me these are birthday cards. The word "retro" tells me what the card collection is and I can already visualize this card line. Rather than just numbering the cards 1, 2, 3, I added additional words (crazy, goddess, age) to refer to the text and theme of each card. Now all I have to do before I send them to a company is add my name at the beginning of the file name. You might find these tips useful when organizing your image files.

Submitting art through postal (snail) mail.

If a company prefers art submissions by mail, rather than just stuffing a large mailing envelope with a variety of items, you might instead create a promo folder. This is a good way to organize your information so that when it arrives, the recipient can move it easily from one desk to another. They can also file it, open it easily, and keep everything together in one unit.

Here are some things you might want to include in a promo folder. And of course, always make sure your name, contact information and website are listed on each item, even if you have to write it by hand.

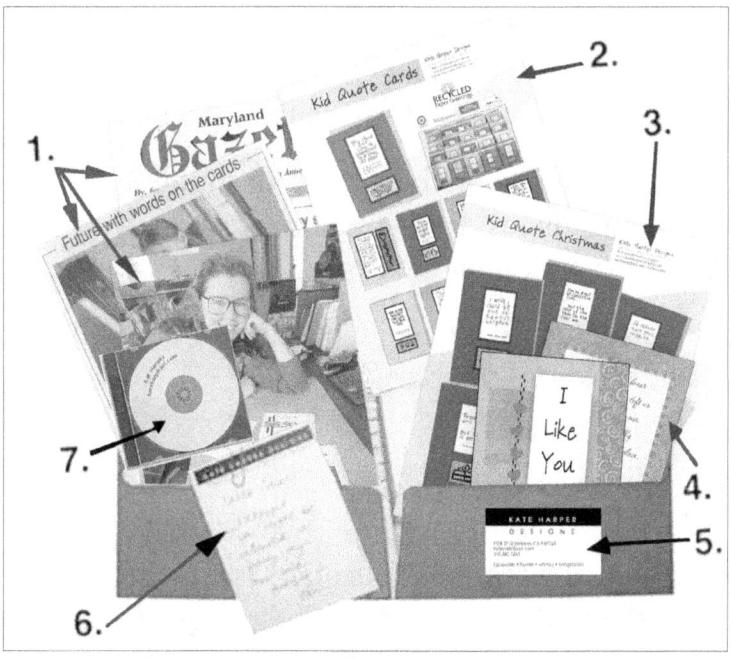

#1 Articles about you and your designs business (if available).

#2 A photo of your products on a shelf. If you don't have one, perhaps a store will let you borrow their shelf for 10 minutes to do a quick photo shoot of products.

#3 Your image submissions, either individually and/or in a group.

#4 Samples of a printed card that you have designed in the past (if available).

#5 A business card.

#6 Clip a handwritten note onto the front of the folder. People are more likely to read a quick

personal notes rather than a long letter of introduction. You can add a bio or introductory sheet inside the folder

#7 You can also include a CD or thumb drive of your images. Remember to write your contact information on the disk.

You can also adhere an image on the front of your folder such as a sticker of your art.

Submission layout

One way to submit card designs is to send them on an 8 ½ x 11 sheet of paper, one card per page. Companies have often told me they like the way I submit cards because all the information is included on the page so it is easy to print it out and take into to a meeting. I usually include the image, verse, optional verse, date, occasion, and contact information all on one sheet.

Submitting your art through an online form.

Here is an example of a form you might find on a company website. The button at the bottom allows you to upload your art files. Normally a company prefers low-resolution images.

FIRST NAME

LAST NAME

EMAIL ADDRESS

PHONE

COUNTRY

MESSAGE

ATTACH FILE
[Choose File]

Submitting by your website.

Today it is expected that an artist has a website if they want to do licensing. Companies may want to review your art on your website, rather than have you send them submissions.

Catalog Sheets

When submitting individual images digitally or in print, it's also nice to include a catalog sheet (also called "tearsheet or "cover sheet"). A catalog sheet displays all the cards in your collection on one sheet of paper. You can usually fit six images on a catalog sheet. This allows the company to view the entire collection on one page before looking at the individual images at full size.

Catalog sheets give you an opportunity to name the collection. Be creative with your title. If you have a collection of birthday cards with a floral theme, "Birthday Garden" might sound more interesting than just "Birthday cards."

You can create titles that are attention grabbers that might make a company ask, "What is this about?" Here is an example of a catalog sheet I made for a collection of graduation cards.

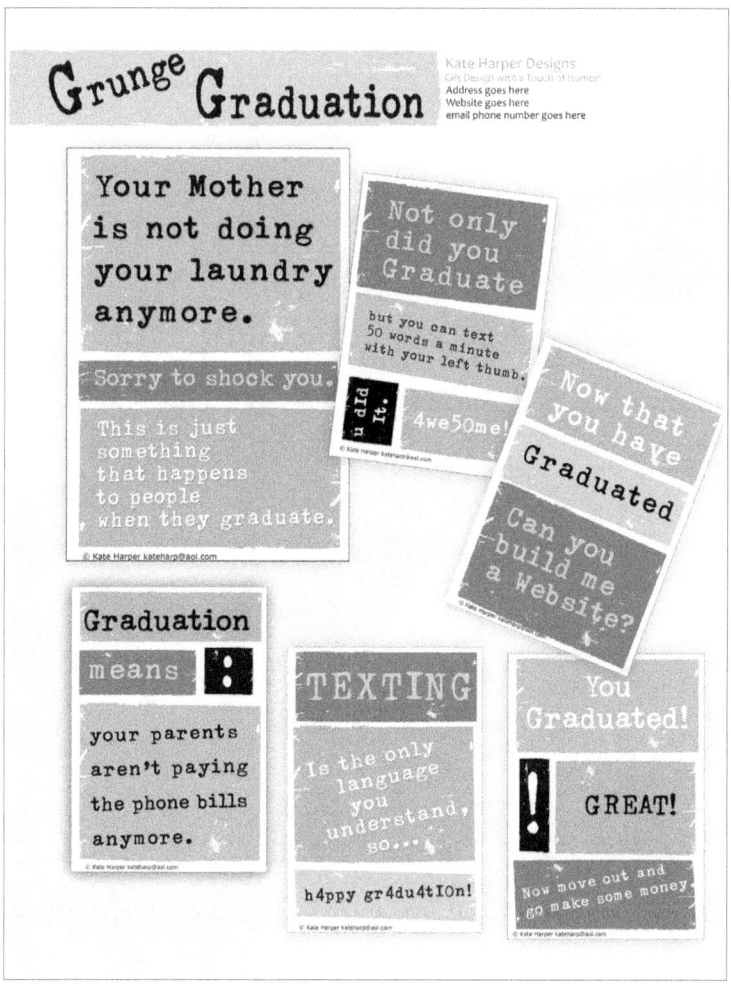

KATE HARPER

STEP FOURTEEN: SET UP A MONTHLY SUBMISSION SCHEDULE.

You might have questions about when, where and how often to submit card designs. What has worked for me is to submit a collection monthly to several companies. If you find that is too difficult, you could start by sending six quarterly.

In terms of how many companies you should send your designs to, you might start with a list of ten and slowly build up to 50.

You can divide your list into three subgroups:

Group A: Companies you already license to.

Group B: Companies who has expressed interest in your work, or requested to be on your mailing list (but you have not licensed anything to yet).

Group C: Companies who you think your cards would fit well with, but they have not responded yet to any submission you've sent.

At first, you will have many companies in group C, but over time, they will move up into the top two groups. Try to make sure no company is in more than one group, so you don't accidentally send the same designs twice. The purpose for separating groups is that it helps you prioritize who are the most important companies to send to, and how personal to make your submission. For example, in groups A and B, I always make sure to have the most recent updated information of the contact person and write personal messages directed to that individual. In group C, you might find that their email does not work or you need to do more research on the company. You can set aside a day just to work on those kinds of issues with group C.

Don't be discouraged if you submit designs to the same ten companies in group C for months, but they never respond. Sometimes they only look at submissions at a certain time of year or perhaps their staff has changed and they are going through a transition. Sometimes this can be an advantage if the new art director is more open to looking at new concepts.

A general rule of thumb is to keep sending submissions unless someone tells you to stop. If you are sending files digitally, it doesn't cost you anything to send submissions, so you might as well do it. I always try to write different messages to each company and avoided sending bulk email that might come across as spam.

Companies may not respond to a submission, so it's not productive to wait around for one company to get back to you before you submit the same designs to

another company. I just send everything out monthly, and use the first-come-first-serve method. Other companies and artist do things differently, but I've never had a problem with this system.

It is easy to send the same designs out to everyone at the same time, but sometimes companies want to see different kinds of art at different times of year, so then you need to keep a list of who you sent what to and when.

If possible, try to get the most detailed submission schedule available from each company. If you send Valentine's cards to five different companies in January, it's possible that one of those companies might prefer to see Valentine's cards in March (for the following year's release). In this case, you can send a substitute collection to one company, of birthday cards that you were originally planning on sending out in March.

The most basic way to keep track of this is to just make a checklist of which company got what, and when. On the check sheet below, company C did not want Valentine's cards until March, so I rotated the January and March cards for that company. I sent everyone Valentine's in January except company C. Instead I sent them the birthday cards.

	Jan	Feb	Mar
Company A	Valentine	Thank You	Birthday
Company B	Valentine	Thank You	Birthday
Company C	Birthday	Thank You	Valentine
Company D	Valentine	Thank You	Birthday
Company D	Valentine	Thank You	Birthday

This is actually a very easy way to keep track of submissions. My experience has been that companies look at seasonal cards about 12 to 16 months before the holiday. For example, if you submit Valentine cards in January of 2017, they will be available for purchase in January of 2018.

STEP FIFTEEN: LEARN PHOTOSHOP

Even if you create all your art by hand, it is important to learn how to use graphic software for submissions and editing. If you have a choice of which program to learn first, I suggest Adobe Photoshop. Almost every artist and greeting card company I know who does licensing uses Photoshop. It's worth the time and effort to learn, and it is also useful for doing any kind of design job beyond greeting cards. This does not mean you have to create your art on a computer, but if you need to change the size, color, shape or save the file in a specific format, it is easier to do it in a graphics program like Photoshop.

Adobe, the company that makes Photoshop software, has changed the way they now sell the program. A person used to be able to buy it on a disk and load it onto their computer, but now adobe has moved to a subscription based model with a monthly fee. If you don't want to sign up for a subscription, then look into buying an older version of Photoshop on a disk, and make sure they work on your computer operating system before you purchase it.

If you aren't able to acquire Photoshop at this time, here are some free software options you can try: GIMP, Paint.NET, Seashore, Pixlr, PicMonkey, SumoPaint, Krita, CinePaint, GrafX2. And here are also some low fee options: Serif Photoplus X7, Paintshop Pro X7, Pixelmator.

While all these programs have multiple functions, you may only need to learn these basic things when you are beginning:

- If your art is all handmade, learn how to scan your images into the computer at different resolutions and formats.

- Learn how to change a resolution. For example, from 300 to 72.

- Learn how to create different file formats from your original image. The most common ones for licensing are: tiff or tif (tagged image file format), jpg or jpeg (Joint Photographic Experts Group) and psd file (Photoshop).

- Learn how to resize an image into different dimension, such as 5x7 to a 2x3, or a square into a rectangle. This is something I found to be helpful when converting my designs into dimensions for magnets.

- Learn how to change colors on your artwork. For example, changing the color of flowers or a part of a pattern.

When you first learn Photoshop, it might be challenging since there are so many features. Sometimes

it is hard to know which one's you really need to learn. I took a class at the local adult school and explained to her what I needed to do, which was edit and format files to submit to companies. This saved me a lot of time and I found out that I didn't need to spend a lot of time learning the entire program. I only needed to use about 5% of its functions.

Some of the best classes are at low cost, local adult schools or community colleges. If all else fails, watch youtube videos online or hire a graphic designer for an hour just to learn how to do one thing at a time. Start by learning how to make a jpg.

It you talk to 100 different artists, you will probably find a 100 different ways to scan, create or change art using graphic software. I am just recommending one of many ways that has always worked for me.

STEP SIXTEEN: GET LEGAL ADVICE

When I first started designing greeting cards, I talked to an attorney about copyrights and contracts. Sometimes artists avoid this step because they think it is costly, but there are several ways to do this without incurring a major expense. Here are some suggestions to explore for low cost legal advice.

Lawyers for the Arts

Most states have nonprofit organizations that helps artists get legal assistance. Their inexpensive fees are well worth the price. When I first visited California Lawyers for the Arts, their organization had a special called "20 minutes for 20 dollars." These fees support non-profit organization and the attorney volunteers time for free.

Your Local Library

Libraries have changed in the last decade. They do

more than just loan books. Some of them lend tools, teach computer classes and offer exercises classes. And some have "talk to a lawyer nights." See if your library has services like this. If not, ask them to add it!

Attorney's free advice

Don't be shy to ask an attorney if they ever offer low cost or free advice for first time visitors. Many do because it is a good way to attract new clients.

If you live in a rural area or don't have access to a contract attorney who specializes in the arts, most contracts can be reviewed remotely by phone and email. Even though my attorney is fifteen minutes from my home, most of our communication is through email. I can send him a contract and he will edit it or point out concerns and mail it back to me. This saves us both a lot of time, and lowers my expense.

When you evaluate attorneys, find one who has experience in copyrights and contracts.

Contracts

I heard an interview with a top selling card designer who was asked, "what is the most important thing an artist needs to do to succeed in licensing?" She replied, "Talk to a lawyer before signing any contracts."

Most companies are easy to work with and have fair terms on their licensing contracts, but once and awhile I've run across a contract where the fine print required I

give up all my rights to my art. This is a big disadvantage because if you lose all rights, you cannot use it again. You also give up the possibility of getting multiple royalties from the same piece of art when placed on different products.

I have signed contracts that are one page long and ten pages long, and some have a complicated list of terms. My first contract was one of the long ones, and I no idea what most of the terms meant, so I felt it was worth the investment to have an attorney look it over. One thing he pointed out to me was length of the agreement. It was for five years. He though it should be for one or two years. He had concerns that if the company only used my art for a year and then decided not to use it anymore, my royalties would drop to zero and I'd have to wait for four more years for the contract to expire before I could get rights to my art back. I would not be able to offer the card design to another company for possible licensing. He said my designs would be "held hostage" until the five year time period was over.

But I was excited about my first contract, since it was with a large, well respected publisher and they were planning to give my card line it's own "featured artist" section in a large retail store chain. I took the chance and signed the five year contract.

But in the end, he was correct to be concerned, because something happened that surprised both of us. The company filed for bankruptcy and a bigger company bought them. The new company replaced my cards with a different line.

When companies file for bankruptcy, sometimes they

don't always have to honor contracts. At this point I understood what it meant to have your designs "held hostage." I had signed away one of my largest card lines of 120 designs, but they had rights to keep them for five years, even if they never published them. But my attorney gave me great advice again and asked them to end my contract early because of the new, special circumstances of the bankruptcy, and to my relief, they agreed.

From this experience I learned some very important things: 1) Look at the length of contracts. 2) Don't offer too many items at once and 3) don't be afraid to ask for a change in a contract.

There are entire books and classes about contracts that go into depth about how to structure them, read them, and what should be in them. They explain much more than I will in this book. Every artist has had a wide array of experiences with contracts, so I am only going to point out a few things I believe are the most important things to look at, based on my own experience.

- Contracts should always have an expiration date (or termination date) for how long they are going to use your art.

- Contracts should list a royalty amount (usually based on the wholesale price). I have found that royalties can range from 3-10% and the average being around 5%-6%.

- Contracts should list the type of product you are licensing the art for, such as greeting cards. Some greeting card companies might also want to license your art for coffee mugs or magnets. These items should be listed on the contract separately and you should receive royalties for each item, even if they are all using the same art.

- The contract should also identify the specific piece of art being licensed. If you have six different red rose designs, then you need to specify which one is being licensed. In a case like this, there are many ways you can identify a piece of art, such as reference number or photocopy attachment.

- Exclusivity is something most companies request. This means you will not license the same design to a competing company at the same time. Once the contract expires, you can relicense it to a different company.

- One exception is that you can often license the same design to another company if that company makes a different gift item. Theoretically, you could license your rose image to a greeting company, and also to a poster company. The same image can be licensed on different products at the same time.

- Avoid agreeing to "sublicensing." This means the company can make agreements on your behalf with other companies. For example, if

you agree to a license your red rose to company #1, this means they can license your art to other companies number #2, #3, #4, etc. Often, your royalty for #2, #3, and #4 is a fraction of the royalties of #1. You also narrow your opportunities to license at other companies on your own. You may give up control over what products your art goes on or how to even locate it in stores.

Probably the most important lesson I learned from my attorney was not to be afraid to edit a contract that has been presented to me. Usually company contracts are boilerplates they give to all artists, and some of the terms are negotiable. Whenever I've requested a change, the company was agreeable, but I am also a person who is not very picky.

Copyrights

If you start licensing your art, it is important to consider filing copyrights. Artists sometimes tell me it's too expensive or they don't want to go to court, but it's not that difficult or costly.

Cost

If you file online, it's only $35, and often you can file several images as a package, such as a card line or collection in one group for $35.

Infringement

I've been involved in many kinds of artists groups over my lifetime and eventually the topic of art theft comes up. Whenever this happens, I can pretty much predict what is next. Everyone has an upsetting story to tell, time zips by and when the meeting ends, we discover there was no time left for showing our art or having supportive discussions.

Most artists I know who have had their art used without permission admit they experienced much more emotional trauma over the event than any financial loss.

From the stories I've heard, I find that most "thefts" are propagated by people I call "the clueless". I have found my art on websites like Cafe Press and Zazzle, where individuals put my design on a product to sell. It's doubtful they've made much money, but it still feels infuriating when you find this has happened.

In my Photoshop class, the instructor spent an entire hour discussing copyright law because so many students were uninformed about what you can or cannot use. She said that most people understand that it is wrong to walk over to another student's desk and grab their watercolor painting and take it home, but these same people don't think it's a big deal to use images from the web.

On the other end of the spectrum, I have met artists whose designs were illegally picked up by a foreign manufacturer who made a product and sold it in the United States. In this case, you can claim a clear financial loss.

I spoke to an attorney who is very knowledgeable about international infringements and he said that while it could be hard to sue a business in a foreign country, you can sue a U.S. company who buys the product. You can use the concept of parallel imports of the trade act, and stop the art from being imported. Infringing material can be stopped at the ports of entry.

Some artists have told me they are afraid to submit art to publishers because they might steal it. The odds of this happening are extremely small because no publisher wants to be in lawsuit with an artist. Not only does it reflect badly on the company, but also other artists will avoid working with a company who knowingly engages in this type of activity.

Remember, just because you see something that looks like your design, it may not be stolen. With all the people in the world, it's possible for two of them to draw the same thing. Ask before assuming the worst.

My attorney gave me some great advice, which made me laugh: "If someone steals your art, just hope it is a big corporation that makes a lot of money from it, because I would love to sue them."

If you find your art is being used or sold illegally, try to replace your emotional reaction with taking action. Immediately send a cease and desist notice to the infringing party. If you find your art being sold online at a company like CafePress, contact them. They may not realize the art on their site is an infringement. My experience has been that these sites are responsive to removing items, and will sometimes ban the seller from the site again.

Here is an example of a simple cease and desist notice:

CEASE AND DESIST NOTICE

Your intentional publication (Artist) of art on the (website name and location) of the following image (your image and/or website with posted image) is a willful act of infringement, and creates the prospect for significant liability under the Copyright Act. You may not be aware that the owner of a copyright may be entitled to up to $150,000 for each willful act of infringement of a registered work, plus the attorneys' fees and costs incurred in pursuing an action against the infringers.

Accordingly, pursuant to this letter, notice is hereby given to you to immediately cease and desist from any publication of this artwork.

Represented by (Attorney name if you have one).

(Your name and contact information)

If you feel the infringing party is not responding to your requests, then contact your attorney and evaluate whether your case should be pursued by filing an infringement injunction or lawsuit.

Court

Very few copyright infringements actually end up in a courtroom. Only 1% of cases go to trial because most are settled out of court and the artist wins a majority of the time.

Suing someone does not always have to cost you money. If you have a good case, you might be able work with an attorney on a contingency basis. Even if they can't collect from the infringer, if there is a third party involved, you can recover damages from them. Only on rare occasions is a registered copyright holder left high and dry.

I encourage artist to not get overly distracted by stories of infringement. Terrible thefts don't happen as often as we fear. Just like overly sensationalized crime stories: they are rare, they are terrible, and the news talks about them all day. Then we conclude these crimes are happening everywhere all the time.

What I believe is much more important for artists to pay attention to, are legal contracts. Don't give away all your rights. One design can generate significant income, especially when it is applied to several products. That is a much bigger loss than a random person trying to sell your

art online.

But if you have been burned, try not to let this hold you back from showing your art again. You can either do something about it or not, but eventually you need to move forward so you can pursue a design career.

STEP SEVENTEEN: LOOK INTO AGENTS

Agents play an important role in art licensing. They represent artists and acquire contracts in exchange for a proportion of your royalties. They usually have personal contacts with companies and often display your artwork at licensing trade shows. For some artists, this arrangement is ideal, because the agent does all the marketing and contract shopping.

Here is a list of agents who have artist submission guidelines on their websites. If you want to work with an agent, you will need to submit your art to them. If they agree to represent you, the agent will be the go-to person between you and the publisher.

Notice in these following agent guidelines how each one differs. Some are very specific about what they want you to do and not do. Many also ask the artist to give them several months to respond because they only look at submissions in batches at a certain time of year. Pay particular attention to words they have capitalized. I can

only assume they have had problems with this request in the past.

Agents

Note: The following agency guidelines, web pages, and contact information may change. For the latest updates, look on their website and locate their current artist guidelines. You usually can find links to updated guidelines under "About," "Contact," on the bottom or sidebar of the website.

Art in Motion

www.artinmotion.com

We prefer to begin with website submissions. Submissions can also be sent by post mail. PLEASE DO NOT SEND ORIGINAL ARTWORK OR SUBMISSIONS ON CD, DVD OR USB DEVICES. Please send a wide variety of selections so that we are able to see the full range of your body of work. To mail us your submission, please click here to download a printable form and include it with your submission. We cannot return submissions. Send photos or photocopies only.

ADG Artistic Designs Group

www.artsdg.com

We prefer to see six to ten pieces of artwork upfront when reviewing an artist's work. Please send either a group of low-resolution jpgs, or a pdf binder attached to an email. Send the email to info@artsdg.com. You can also send a link to an online portfolio if you prefer. Keep in mind, we may only perform a review every 4-6 weeks and we only select a few artists for further review each year. We do try to respond within a reasonable time

frame and prefer that you do not call directly unless we indicate we would like to review your work for consideration.

Artworks Licensing

www.artworkslicensing.com

Please submit your work in one of two ways:

By Email to: info@artworkslicensing.com Send low-resolution jpegs or PDFs are acceptable for review. Include your email address, web address, and contact information. By Mail send to: Art Submissions, Artworks! Licensing, Post Office Box 2028, Jupiter, FL 33468 Color prints and/or disk (CD of jpegs/PDFs) are acceptable formats. In both instances you should include a brief bio including licensing experience, if any. Also, please provide any samples of your design ideas applied to products or licensed products that have already been produced. If you would like your samples returned, please provide a self-addressed, stamped envelope with your submission.

Bentley Licensing Group

www.bentleylicensinggroup.com

We look for new artists and photographers to expand our portfolio of images. If you would like to submit artwork you can email submissions in the form of jpeg, tiff or pdf files to: artsubmissions@bentleylicensing.com Include your name, email address, website, phone number and a

biography if available. If mailing a disk of your artwork send to: Bentley Licensing Group, Art Submissions, 15 Crow Canyon Court, Suite 210, San Ramon, CA 94583. If you want your material returned, include a self-address, stamped envelope. Please DO NOT SEND ORIGINAL ARTWORK. If we are interested in your work we will contact you. Please allow six weeks for this process.

Courtney Davis

www.courtneydavis.com

We welcome the opportunity to review your body of work. We ask that you please send us a representation of your artwork via a jpeg or PDF file or send us a link to your website. Please forward these files to info@courtneydavis.com . It is important that you show a large variety of images. PLEASE, DO NOT SEND ORIGINAL ARTWORK to our office in Franklin, Tennessee. We meet monthly as a committee to review all submissions. Once we have completed our evaluation process, we will be contacting you.

CP Licensing

www.cplicensing.com

We prefer the initial artwork review to be online. If you have a webpage, please send a link. If you do not have a webpage, send an assortment of jpegs that show the range of your work. Include different subject matters, styles and techniques. Send to

chris.peterson@cplicensing.com . We will contact you after reviewing your artwork.

Creative Connection, Inc.

www.cciart.com

Please submit a few samples that represent your style(s). We prefer to receive jpegs by email or a link to your website for initial review. If you would rather mail promotional sheets or color copies, include a self-addressed stamped envelope if you would like them returned. We will let you know if we need additional artwork for review. Our review process can take two to four weeks depending upon time of year and the amount of submissions we have ahead of yours. Our preferred method of contact initially is email, so include an email address with your submissions. We are full, however, we will still review your submissions. You may have something we lack, or we may ask you to resubmit at a later date if your art is compatible. We do not represent photography, advertising, entirely graphic or cartoon styles of art. Please review our website carefully to see if your art fits in with what we offer. If you feel your art is compatible and that it does not overlap too closely with what you see on our website and it is of the caliber of art that we offer, we will be happy to review your work.

Cypress Fine Art Licensing

www.cypressfineart.com

Artists and photographers are welcome to submit art for

consideration. We seek art that is suitable for the home decor, giftware and stationery markets. Some categories of particular interest are florals, wildlife, country, whimsical, decorative, religious, inspirational, fantasy and black and white photography. If you have a website we will be happy to view your art on-line. You may also send photos, color copies, brochures, 35 mm slides or low res CD rom. Please send a postage paid self addressed envelope for any art that you wish returned.

JMS Art Licensing

www.jmsartlicensing.com

Please e-mail your web site link or send us some sample attachments (PDF or JPG formats please). If mailing submissions, do not send originals. CDs should include a thumbnail printout of images with titles. If you would like to have your work returned please include a self-addressed stamped envelope. SUBMISSIONS WITHOUT A SELF-ADDRESSED STAMPED ENVELOPE OR INSUFFICIENT POSTAGE WILL NOT BE RETURNED! Sorry, there are no exceptions. Send submissions to: JMS Art Licensing, 1630 VT Route 30, Pawlet, VT 05761

Leo Licensing

www.leolicensing.com

Artists wishing to submit images for review by Leo

Licensing may do so in one of the following ways. 1) Mail a disc or color copies to the address below--no originals please. Send a self-addressed, postage paid, return envelope if the work is to be returned to you. 2) Email .jpeg images at 72dpi to: jane@leolicensing.com. These images will be used for review only. Mailing Information: Leo Licensing, 8573 Medlin Road, Baxter, TN 38544

London Portfolio

www.londonportfolio.com

We are always looking for highly innovative artists who are professional and dependable. London Portfolio has been representing artists for 25 years and both sells and licenses designs for stationery (greetings cards, shopping bags, wrapping paper, journals), textiles, ceramics, and just about anything that can be printed. The work which we receive and sell is both digital and hand drawn. If you are interested in working with us please fill in the artist submission form here on our website: http://londonportfolio.com/new/artist_submission.php

Magnet Reps

www.magnetreps.com

Applicants should have a well developed unique style, a passion for their craft, a desire to work hard and

experience doing illustration on their own. Submissions must be described as a representation request in the subject line of the email, promo emails with no representation request will be deleted. How - Email a link to your website, 4 low-res jpegs or a low-res pdf. We prefer to visit your website for it shows off more of who you are. We do not represent scientific, technical or medical illustrators, hyper-realistic work, comic book, cartoon, storyboarding. We do not represent photographers, graphic designers, art directors, fine artists, storyboard artists or cartoonists. If we like what we see, we'll contact you. Unsolicited portfolios arriving by mail or courier will not be returned.

Meehan Design Group

www.meehandesigngroup.com

If you would like Meehan Design Group to consider representing you and your work for licensing, please email us the following information: Low resolution images and/or a website that best represent the work that you are currently creating. We look for artists that have a cohesive body of work that will translate to consumer products. Brief information about any licensing you have done in the past. The best contact telephone number and e-mail to reach you. We will contact you once we have reviewed your submission to discuss any opportunities that we can explore together. Please be aware that we only add about one artist a year, at this point.

Mosaic Licensing

www.mosaiclicensing.com

We continue to be on the look out for emerging talent and creative brands. Submitting artwork for representation: Please send us a link to your website or an email containing 10 low-resolution jpg images showing a range of your art/design collections to: val@mosaiclicensing.com. We look for established designers and creative brands that have an awareness of trends and colors, and whose work will be marketable to a range of manufacturers in home and gift to lifestyle products. Please do not send ORIGINAL ARTWORK.

MHS Licensing

http://www.mhslicensing.com/

How to Submit Artwork

We are always very interested in new talent and welcome the opportunity to review your work. We receive many art submissions monthly so your adherence to our guidelines will help expedite our response to your submission. Our Art Review Committee will review submissions at a monthly meeting and determine if we should explore working together. We will contact you directly by phone, e-mail or mail. Please note that in some cases it may take up to 6 weeks to respond. If submitting artwork for representation: Please send us a link to your website or an email containing no less than 8 images (via jpeg or pdf) showing the diversity of your

portfolio to: artreviewcommittee@mhslicensing.com. Note: When submitting your artwork it is helpful if you share with us your vision of how your work might look on product. To help reduce the environmental impact of paper, and physical delivery, we prefer electronic submissions via email. However, if you choose to mail printouts of your work, please send them with your name and contact information to: MHS Licensing, Attn: Art Review Committee, 11100 Wayzata Boulevard Suite 550, Minneapolis, MN 55305-5517 If you would like your materials returned after our review process please enclose a self-addressed stamped envelope with correct postage. We will assume that submissions without a postage paid envelope do not need to be returned. Please do not send your valuable originals.

Parcaid Designs

www.parcaidesigns.com

We are always on the look out for new and fresh art talent. If you feel you fit the following criteria, we'd be happy to look at your portfolio. Qualities we look for in an artist: We're looking for artists who understand and are willing to respond to the ever-changing needs of the marketplace. Flexibility: Your design may be terrific for a party plate, but may need some tweaking to look right on a shower curtain. Willingness to work with a manufacturer on requested changes will help get your art on more products. Communication: We will conduct most of our transactions through email and the occasional

phone call. Types of art we are looking for: Any art that can be put on product. We are primarily interested in looking at portfolios with a minimum of 8-10 collections of art. Send us a sample of your art: Email low-resolution images of your artwork to Lainey Parker at LParker@ParcaiDesigns.com. Or you can send a link to your online portfolio to the same email address. We suggest you provide us with two methods of contact. Once we've reviewed your work we will get back to you within 2 weeks.

Penny Lane Fine Art and Licensing

www.pennylanepublishing.com

Submit photos, color copies or a CD to: Penny Lane Publishing, Attn: Artist Coordinator, 1791 Dalton Drive, New Carlisle, OH 45344. You may also send submissions via email to: info@pennylanepublishing.com. Please include "artwork submission" as well as your name in the subject line. Requirements for submissions via e-mail: Send .jpeg files @ 72 dpi; maximum file size 1 MB (not to exceed 10 MB per e-mail). Please send a variety of images (at least 10 images) so we can get a good feel for the type of artwork you have available. PLEASE DO NOT SEND ORIGINAL ART. Important note: You must include a self-addressed, stamped envelope (SASE) if you would like to have your submission returned to you. If a SASE is not included, we will file your submission for our records. We will contact those of you who submitted by standard mail within eight weeks of

receiving your submission. Since we are unable to talk with everyone in depth the following information will provide an introduction to some of the pertinent questions you may have.

PM Design Group, Inc

www.pmdesigngroup.com

Please note that all industries now require digital submissions. Working knowledge of Adobe Photoshop is vital. If you are not computer savvy, you will need to work with someone who can provide these services for you. Please email your query to PMDGservice@aol.com, including a link to your online portfolio or an email containing no more than 8 images (via 72dpi jpegs or pdfs) showing the diversity of your portfolio. Also a brief bio and industry experience would be helpful. We would like to know if your work was previously licensed, with whom (or what type of industries). It would also be helpful to know if you have worked with an agent. We prefer electronic submissions via email. PLEASE DO NOT SEND US YOUR PRECIOUS ORIGINALS. WE CANNOT GUARANTEE THEIR SAFETY! Please note, if you do not hear from us within three weeks, we have looked at your submission and concluded that we are not the right agency to represent your work at this time. If we are interested in seeing more of your work, we will request that you send additional files.

Sagebrush Fine Art

www.sagebrushfineart.com

We are always on the lookout for new artists with new styles, whatever their mediums. With the ever-changing market we work in, we are always looking to expand our group of artists. We prefer your submission to be sent via email to submissions@sagebrushfineart.com. You can send any of the following: Jpegs of your work (at least 20 pcs to give us a good feel of your diversity). PDF of your work (include at least 20 pcs to give us a good feel of your diversity). A link to you your website. All submissions are reviewed by our team twice a month, but things are busy and sometimes our reviews don't happen that often. If we determine we are interested in your work, we will contact you to explain how we work.

Ruth Levinson Design

www.levisondesign.com

While we must limit the number of artists we represent in order to do a good job for everyone, we always have room for someone who is talented and innovative with a portfolio of available, licenseable designs. We look for talented people whose primary occupation is artistic endeavor. Style, technique and subject matter are most important in creating designs marketable to a wide variety of manufacturers. Awareness of the trends in home décor is a most desirable asset. If you are interested in representation, please contact the below number, or

attach one JPEG image to an email and send it to the contact page on our website: https://www.levisondesign.com/contact

Ansada Licencing Group

www.ansadagroup.com

Send your submission to: Attn: Artist Submissions, Ansada Licensing Group, LLC, 8466 N. Lockwood Ridge Road #162, Sarasota, FL 34243, artistsubmissions@ansadagroup.com. Please submit your work in a medium that will show it best. Electronically via email, CD or referral to your website is the best way. When sending via email, please reduce the size of the files or the email may bounce back to you. If you choose to send your submission in the mail, you must include a self-addressed, stamped envelope for the return of the materials. Materials sent without a SASE will not be returned. Please submit a resume and cover letter including your licensing and publishing history, as well your approximate Original Painting sales pricing. Examples of the type of artwork we accept for licensing are wildlife art, nostalgic art and figurative art.

Wild Apple

www.wildapple.com

Please either send a link to your website, or send approximately 6 jpegs (size around 5×7 at 72dpi), via our

submission form on the submission page: http://wildapple.com/submit. If you do not hear from us it means that we are unfortunately not able to use your work. Please don't phone! We're sorry but we can't respond to inquiries via phone or provide individual feedback due to the high volume of submissions received each week.

Here are some excellent articles about agents that will help you determine if it is the route you want to take.

"Questions to ask before choosing an Agent"
http://joanbeiriger.blogspot.com/2009/10/questions-to-ask-before-choosing-art.html

"Do I need an artist's agent?"
http://mariabrophy.com/business-of-art/do-i-need-an-artists-agent.html

"List of U.S. Licensing Agencies"
http://joanbeiriger.blogspot.com/2009/11/list-of-over-50-us-art-licensing.html

"List of Non U.S. Art Licensing Agencies"
http://joanbeiriger.blogspot.com/2009/11/list-of-non-us-art-licensing-agencies.html

STEP EIGHTEEN: GET A PLANNING BUDDY

I first learned about the planning buddy system from an artist friend years ago. She learned how to do it from a book called "Wish-craft: How to get what you really want." It may sound simple on the surface but after doing it a dozen or more times, I believe it will move anyone's life forward quickly. In fact, it is just as important as anything else in this book, and best of all, it's free.

Since licensing requires several small steps that may all be new to you, it is easy to postpone tasks if you get interrupted. Buddy meetings are the way to keep on track and accomplish goals in a short period of time. For licensing, your goal might be to get your first contract.

The basic structure of a buddy meeting is to pair up with another person an hour a week for three months, and each of you work on separate goals. You exchange support, resources and provide accountability. You don't need to have the same goal. For you, it could be getting an art licensing contract, for them, it might be getting a new job or going back to school.

If you can't meet your buddy every week, try 12 sessions on any schedule as long as your leave enough time in between meetings to accomplish a specific task. If you really feel unable to commit to that many sessions, you can at least experiment for a month and see the effect it has on your goal. Then you will probably understand how powerful it is and you will probably want to complete the 12 meetings.

In each session you set a mini goals that is a stepping stone towards a larger goal. For example, if your major goal is to get an art licensing contract, you might start by creating a card line, but that might be difficult to do in a week, so you then break down the task even more. A better mini-goal might be to bring three pieces of art to the next meeting. Or perhaps your goal for the following week could be to read a book and report on it.

If their major goal is to get a new job, they may set this week's goal to bring three job postings to the next meeting. The most important thing is that all goals must be measurable, and they must be recorded so it will be obvious whether the task was completed or not. Saying you "I will design and bring three greeting cards to the meeting" is measurable. Saying "I will work on designs this week" is not measurable. You then come to the next meeting with your results, even if you failed at your week's goal.

It may be hard to understand why this simple practice is so effective, but I've witnessed my buddy meeting partners (and myself) make major life transitions by going through this process.

Here are steps on how to do the buddy meeting

system:

First, find a buddy. They can be a close friend, roommate, or a neighbor. Choose someone who wants an action-oriented arrangement, and not a social event. Don't be afraid to ask anyone. Most people would like to do something like this if they had the opportunity. Find someone who has a goal they want to work toward: starting a business, going on vacation, buying a house, having an art show...anything!

The reason this system works is that it has very specific rules for each meeting.

- Be on time. This sounds like a small thing, but it shows respect for your goal and your buddy's goal.
- Bring a notebook and write down both people's goals every week.
- Use a timer. This will structure the meeting and help you stay on point.
- You meet for an hour (30 minutes each). During the first ten minutes, each of you report in for five minutes and say what you did or didn't do in the past week, and what the results were. Your buddy will have notes from the previous week and will want a know about each item.

In the next 40 minutes you takes turns (20 minutes each) talking about problems you ran into and successes you accomplished. You invite your buddy's suggestions.

It's important to avoid using your time to deal with emotional challenges, or complaining too much. Redirect yourself back to your goals.

In the last ten minutes, each of you have five minutes to select a goal for the following week, which leads to your ultimate goal to get a licensing contract. Then you both write down each other's goals (yours and theirs) so it is clear what you will be accountable for. Your buddy should be able to understand your goal and determine if it is measurable or not.

This kind of meeting does not have to take time away from your schedule. It could easily be done during lunch or over the web, but always limit it to an hour. If you and your buddy want to socialize afterwards, that's OK, just don't mix it into the structure of the meeting.

I believe you will find this process amazingly beneficial in licensing and in most things you want to pursue and accomplish in life.

STEP NINETEEN:
SHOW THE WORLD YOUR ART

Showing the world your art is a fun way of describing marketing. Marketing does not require you scream "look at me and how great I am." Most artists avoid it for that very reason. Rather, marketing is all about letting people know who you are and what you are doing. If people don't know you even exist, that's a missed opportunity. Here are some easy ways to get the word out.

Press Releases

It's easy to get featured in trade publications (step 5). They like to feature new products and artists.

Once you have a product available for sale, you can write press release about your new design.

An editor of a trade magazines told me that if an artist wants to write a good press release, here are some things to pay attention to:o:

1. Send the release to the correct editor. Check the publication's website. It's usually best to send your release to the editor-in-chief, but don't sent more than one to different people at a company.

2. Send release to the correct industry. If you have a press release about your new greeting card line, be sure the publication actually covers greeting cards. Editors at home-furnishings magazines who don't cover greeting cards and shouldn't be on your press list.

3. Send releases at the correct time. Check the publication's editorial calendar which is usually on the website. Then, be sure to send your press release by the editorial deadline date.

4. Send enough information. Editors prefer to run press releases that contain all of the information they need, because they don't have the time to track down missing information. Provide as many relevant details such as dimensions, embellishments or techniques used, verse and retail price.

5. Send a short summary of your company. It's good to include information about your business, but keep it short.

6. Send contact information. Include a website, your full name, company name, email address, address and phone number.

7. Check for typos. If your release includes the wrong website address or contact information, those errors will end up being publicized. And always spell "stationery" correctly (and not stationary). One way

to remember this is that the "e" is also in the word "letter."

8. Send images. Send high-res images of your cards at least at least 3 inches at 300 dpi.

9. Send samples. This allows the editor to see the finished product.

Since sending press releases is another way to get free publicity, it's really a win-win situation for the artist because it requires no financial investment. Advertising, on the other hand can cost thousands of dollars, so it's best to take advantage of the opportunity to write a press release.

Social Media

If you are new to social media, you might start by setting up facebook business page (not to be confused with a personal page). This is a great way to encourage people to follow you and tell them about what you are working on. Even if you only post once a week, it's a great way to get the word out about your designs and interact with others.

Blogs

Some experts on blogging say that the best thing you can do when you start a blog is to allow people to sign up to be on your mailing list. Then you can accumulate contact information from people who want to keep

connected to you.

Artist Who Market Online

One of the most interesting people I ever interviewed who sold her art online was an artist named Laura Barbosa. She created a whole system for marketing her art through social media. Here is an article about how she does this.

http://kateharperblog.blogspot.com/2010/03/selling-my-art-through-social-media.html

You can also read interviews with several other artists I've interviewed who have succeeded in using social media for marketing their art:

http://kateharperblog.blogspot.com/2010/03/social-media-month.html

STEP TWENTY:
EXPAND TO OTHER PRODUCTS

Besides licensing you designs on cards, you can also expand to additional products. Here are a few items that I originally designed as a greeting card, that were later adapted and licensed for other product categories.

Checks

Car Coasters

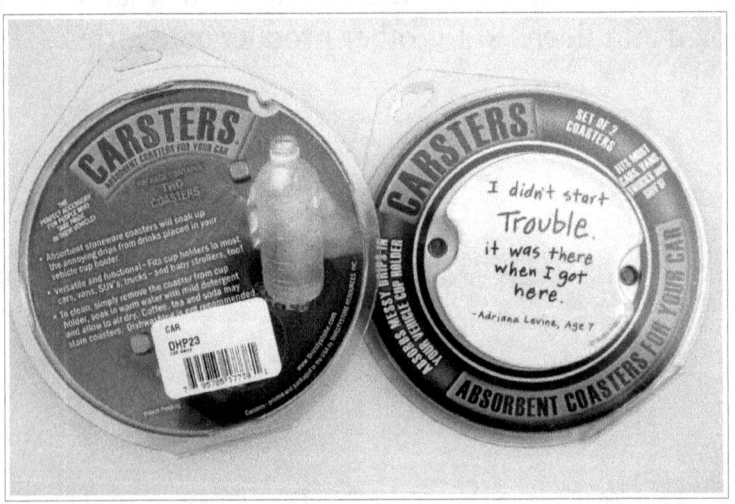

Bookmarks and Magnet Sets

Calendars

Towels

Table Coasters

Mugs

T-shirts

Notepads

Rubber Stamps

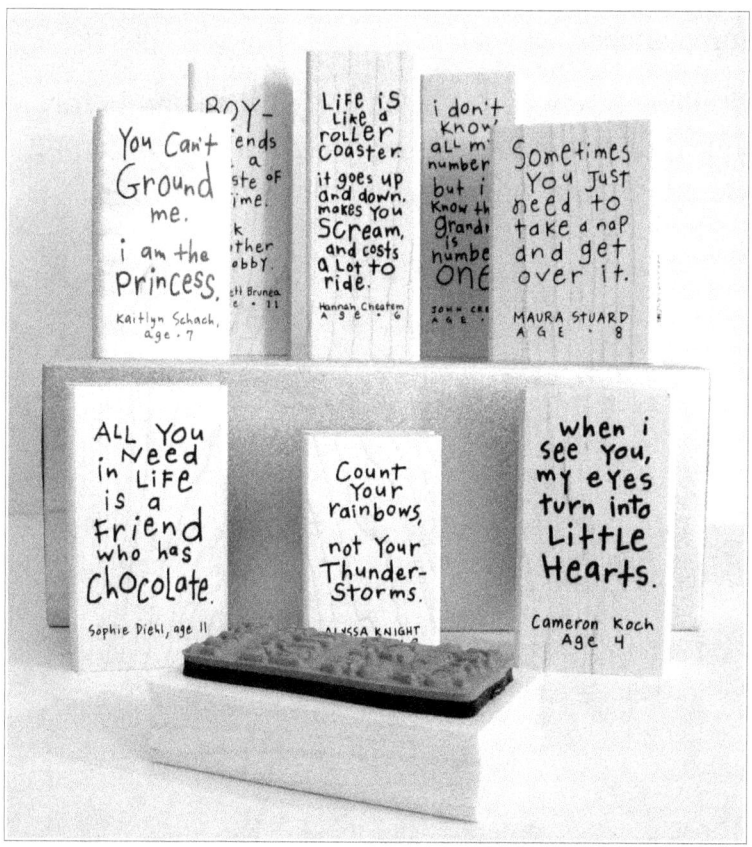

Now you can see how greeting card designs can often be applied to multiple products for licensing such as aprons, tableware, shower curtains, potholders, greeting cards, magnets, flags, rubber stamps, bedding, paper plates, gift bags, rugs, coasters and much more. Remember, almost every design you see in a store was created by an artist. Some of the artist work in-house (as an employee), but many also license from independent artists.

Many gift companies have templates or guidelines for product submissions. This allows the artist to accurately adapt their design for the correct dimensions or special circumstances.

It also allows you to evaluate your design before you submit it to a company. Here is an example of a mug product template where I applied my design.

You might discover when applying art to a template, that some designs are easier that others, such as the mug template. This template requires the art to be curved. My freeform pattern is much easier to adapt than a striped pattern.

Articles on how to submit to specific industries:

Scrapbook Companies
http://joanbeiriger.blogspot.com/2010/07/licensing-designs-to-scrapbooking.html

Tabletop Companies
http://joanbeiriger.blogspot.com/2010/06/licensing-designs-to-melamine-acrylic.html

Quilting Companies
http://joanbeiriger.blogspot.com/2010/05/licensing-designs-to-quilt-craft-fabric.html

Jigsaw Puzzle Companies
http://joanbeiriger.blogspot.com/2010/03/licensing-art-to-jigsaw-puzzle-industry.html

Flag Companies
http://joanbeiriger.blogspot.com/2010/02/licensing-art-to-flag-industry.html

CONCLUSION

Some of the things I suggest in this book may sound challenging, but when you step back and look at all the things you have already done in your life, I'm sure many of them were much more challenging. Art licensing is no different. Success depends on how much effort you invest, how disciplined you are, and how much professional feedback you seek.

Bouncing back is more important than succeeding all the time. I remember hearing an interview with the person who does all the hiring at Google. He explained why he prefers to hire people who graduate from community colleges rather than Ivy League schools. He has found that community college students are not afraid to try things and fail. They take reasonable risks and don't give up if they have a setback. Instead, they learn from mistakes and move on to the next challenge. But he said that employees who come from competitive ivy league schools have often been isolated from failure and may not know how to respond when some something goes wrong. They take longer to recover and have more

difficulty bouncing back.

So, if you create a card line and it is rejected, never lose the opportunity to ask someone, "how can I make it better?" That's a normal part of learning. Sometime we forget that art is part of our daily lives. Every time you visit a website, receive a card, write on a calendar, drink from a coffee mug, look at picture book, and observe millions of things you encounter daily, you will see how art is immersed into everything you do.

Without art, we would experience a different world. Imagine surfing the web and all you could see was green text on a black screen. It wasn't so long ago that this was the case, and very few people were interested in using computers. Then Steve Jobs came along and revolutionized our experience by bringing fonts, images, icons and graphics to the Macintosh.

Art matters. It is not pretentious to say that art is a critical part of our economy. Corporations rely on design for success, and many would fail without it. If surface design was removed from all products today, my guess is that tomorrow stocks would fall on Wall Street.

One of the reasons midcentury modern art became so popular in the 1950's was because people wanted to eat, drink, and sit on art. They didn't just want to hang art on walls. You might call this the beginning of functional art, which is really what art licensing is all about. It is the opportunity to bring beautiful things into our lives and use them everyday.

~

ABOUT THE AUTHOR

Kate Harper is a greeting card and gift designer in Berkeley, California. She is also an adult education instructor and has taught a variety of art classes throughout the San Francisco bay area. She has a B.A. in Art Therapy from Indiana University and an M.A. in Expressive Therapies from Lesley University, in Cambridge Massachusetts.

She has designed over a thousand gifts, greeting cards, magnets, t-shirts, coasters, placemats, rubber stamps, coffee mugs, paper pads, and embroidery kits. She has a special interest in bridging the gap between art and technology, and helping indie artists bring their vision into the marketplace.

Books by Kate Harper

Get Your Greeting Cards into Stores explains how to sell cards nationwide. Included are detailed guidelines on: How to price cards for a profit, get professional feedback, find sales representatives and follow industry standards. Information is also applicable to gift items, magnets, journals, calendars, collectibles, etc.

How to Publish and Sell Your Article on the Kindle is a booklet for beginners on how to publish and sell short documents for the Amazon Kindle, such as short stories, magazine articles, essays, memoirs and instructional materials.

Divorce and Breakup Coloring Book If you are woman who is divorced, or perhaps you are going through a breakup, this coloring book will help you keep a smile on your face through all the ups and downs. Includes: 30 full page images, 10 foldable notes on how to enjoy being single, and 10 small frameable images ideal for a gift. This coloring book has all original art, playful patterns, and lighthearted quotes. It is designed with the belief that any woman can get her groove back! Artwork is by greeting card designer, Kate Harper, with multiple contributing writers.

Designs and Patterns from the Atomic Age is a coloring book that will let you time travel to the Atomic Age of Design. These irregular shapes and patterns represented hope on the forefront of a new era of technology. Later, they evoked a calming sense of longing and nostalgia for simpler times. Now, these happy and cheerful patterns may be just the thing to get you through your day. Includes 60 Images: 20 full sheets, 10 stationery pages, 10 envelopes, and 20 4 1/2 x 6 frameables. Maybe you saw these themes from the 50's and 60's featured on TV shows, propaganda films, cut scenes, and the various stylings from the Fallout franchise. These mid-century modern designs have delighted Americans during some of the most tense chapters of our history. Modern life is full of pressures and stresses. Today, we face decisions and doubts that our forebears did not confront. This book will let you time travel to the Atomic Age of Design and help you calm and center yourself. Enjoy coloring for the whole nuclear family!

7 Mistakes Greeting Card Writers Make is a booklet that explains what to avoid when submitting greeting card verse to publishers. Learn how to create a trendy card that reflects the contemporary world we live in, and how to use your own personal experience to create card verse. Topics include: how to avoid limiting your market, when to use adjectives, not creating card for enemies, write like people talk and a list of why card sentiment submissions are often rejected. You can increase your odds of success by 60% just by doing a few simple things. Includes a list of card publishers and their guidelines, links to writer interviews, and writing exercises for how to create good verse.

Unusual Ways To Market Greeting Cards, and 22 places to get your designs featured is a booklet on how to get your cards noticed in non-traditional ways. Everything from why you should send cards to your dentist, to how to get a special feature in national publication. Great tips for designers who are starting out and want to get their cards into the hands of people beyond friends and family. Special Section: 22 Gift Industry Trade Publications who seek out new greeting card designs and feature artists for free.

How to Make an EBook Cover for Non-Designers is an illustrated book will show you how to make your own e-book cover, even if you are not a designer. It is intended to help the indie writer who is on a budget and wants to publish and sell their own book in online stores such Amazon.com and the Apple ibookstore. Selling your book in these stores will allow readers to purchase your book and read it on multiple devices such as the Kindle, iPad, iPhone and many other electronic devices.

20 Steps to Art Licensing is a book about how to license your art to companies that publish greeting cards, or manufacture coffee mugs, magnets, wall hangings, kitchen items, and dozens of other gift items. Learn how to prepare your art, what companies to contact, how to find agents, and what trade shows to attend. Includes extensive resources on social media, copyrights, licensing community groups, and lists of interviews with professional designers

Copyright © 2017 Kate Harper

All rights reserved.

www.ingramcontent.com/pod-product-compliance
Lightning Source LLC
Chambersburg PA
CBHW071430180526
45170CB00001B/290